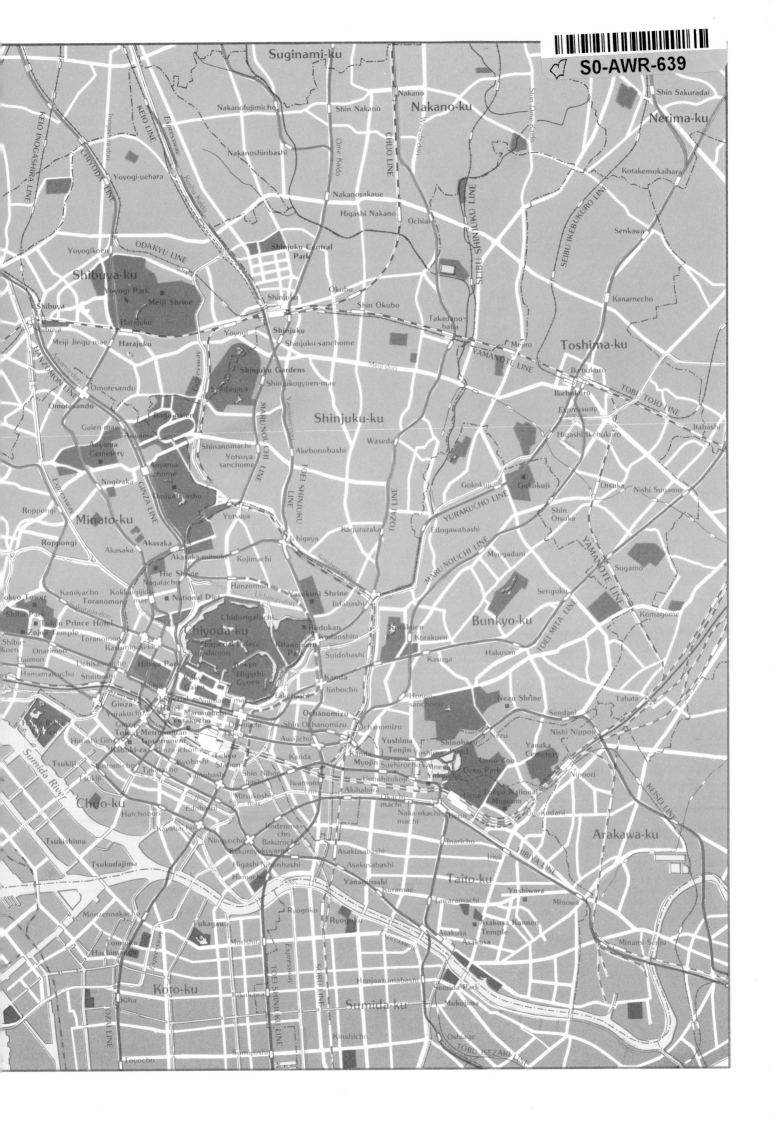

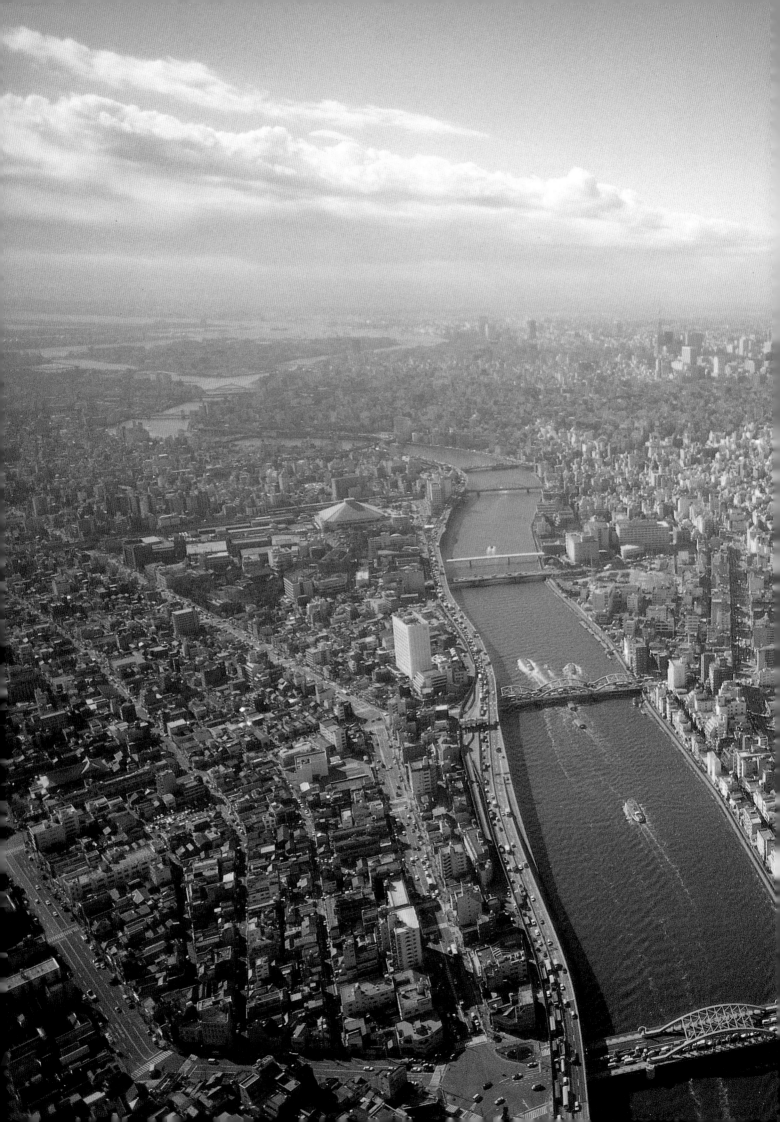

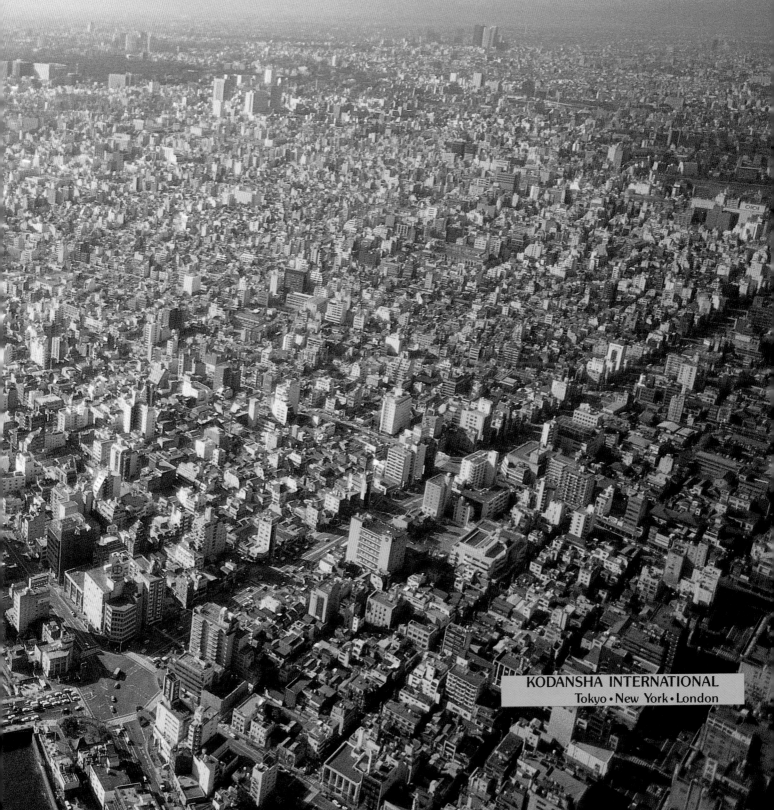

INTRODUCING
TOKYO

Text by **Donald Richie**
Photography by **Ben Simmons**

KODANSHA INTERNATIONAL
Tokyo • New York • London

for Eric Klestadt from Donald
for Deborah Kolb from Ben

The publisher wishes to express its gratitude to the following for their assistance: Kodak, Tsuru Enterprizes, Japan Airship Service, Kodansha Photo Library (for additional monochrome photographs), Mitsubishi Bank, and Yurakucho Seibu.

Distributed in the United States by Kodansha America, Inc., 114 Fifth Avenue, New York, N.Y. 10011, and in the United Kingdom and continental Europe by Kodansha Europe Ltd., 95 Aldwych, London WC2B 4JF. Published by Kodansha International Ltd., 17-14 Otowa 1-chome, Bunkyo-ku, Tokyo 112, and Kodansha America, Inc.

First hardcover edition, 1987
 98 10 9 8 7
First paperback edition, 1993
 98 5
LCC 86-40436
Hard: ISBN 0-87011-806-4 (U.S.)
 ISBN 4-7700-1306-X (Japan)
Paper: ISBN 4-7700-1798-7

Contents

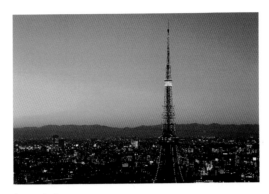

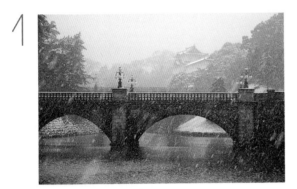
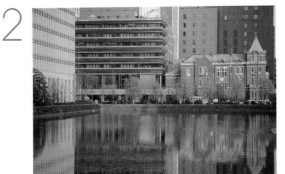
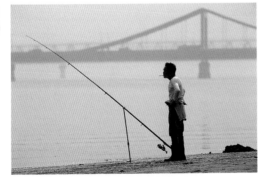
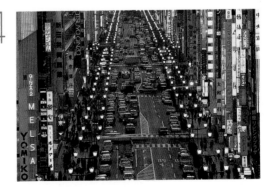

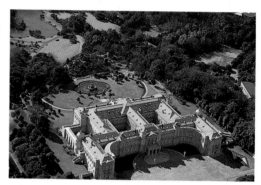

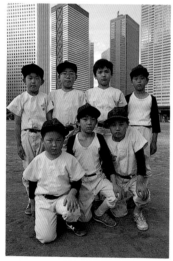

Introduction

There is no Japan like Tokyo.
—Lafcadio Hearn in a letter to Sentaro Nishida
January 1895

While writing this book, wandering around and thinking about this city in which I have lived for forty years now, I happened to meet an informed newcomer and incautiously mentioned the charm of Tokyo.

The charm of what? he wanted to know. Tokyo? This graceless capital, largest city in the world and the least distinguished, home of twelve rushing millions, three out of four born elsewhere?

Why, within a thirty-mile radius of the Imperial Palace, he informed me, live twenty-eight million people. And that is more than the entire population of the state of California—three million more!

Before I could protest, the informed newcomer continued with: And besides the hordes, Tokyo is a charmless clutch of structures, myriads of them, which seem more accumulated than constructed. The newer and the older are crowded together with no apparent reason; the effect is entirely haphazard; there are no real vistas, no real views; there is no real sense of a great city.

The architectural style, in that there is one, has no name, though one might call it Tokyo Impermanent. The effect is that of an international exposition—several years after it has closed. There is the same urge to attract the eye for the moment, the same inclination to sacrifice any idea of unity to the frivolity of a wild diversity.

And this air of impermanence, he went on, is defined by the fact that the city is forever under construction. Half of it is being torn down while the other half is being reconstructed. Tokyo will never be finished!

No, no, he finally concluded, Tokyo is not charming—it is simply not beautiful.

Well, I thought, he had obviously come prepared. And much of what he said was true enough. This enormous number of people all in one place, for example. It has created Tokyo just as the sea created Venice, and the desert, Timbuktu. And the city's mottled architectural aspect, its thousands of little oddly shaped units, is a reflection of an increasing population and rising land prices. Land has become so valuable that putting anything very permanent on it is uneconomical, hence the great rate of routine tearing down and putting up. Tokyo is a real metropolis, substandard housing and all.

Yet, true though the informed newcomer's statements were, his conclusions were not. He had absorbed the facts, but these do not properly describe the city. Tokyo is more than all of that and even something further.

Tokyo is not beautiful, but then, while it may pretend to be a number of things, modern Tokyo has never pretended to be beautiful. Beauty, after all, implies a certain balance, a kind of repose. And Tokyo certainly has neither of these—nor does it have any celebrated views or picturesque spots.

Beauty depends upon integration, and as architectural critic Peter Popham has noted, the fundamental reason "for Tokyo's ugliness is that it lacks all integration." However, as he goes on to say, perhaps consequently the integrative failure of Western cities "has not touched Tokyo at all, as there was nothing to damage in this way."

This lack of beauty is tacitly understood by Tokyoites, and much laughter was occasioned by a recent official objection to yet another highrise in the Marunouchi district. It would, it was said, ruin the beauty of Tokyo's skyline. What beauty? asked the editorials. What skyline? queried the weeklies.

No, Tokyo, unlike Kyoto or Kanazawa or any other Japanese city famed for its beauty, was never planned. Or, rather, though once planned (both castle and the surrounding city of Edo—as Tokyo was originally called—were designed at the same time) this master design was soon obscured. Indeed, a part of the dynamism of Tokyo results from this tension between the once-planned and the unplanned.

With many exceptions—the Ginza, for example—the streets are not straight, blocks are not square, neighborhoods almost never seem designed. Though the Imperial Palace forms a core, it no longer feels like one. Rather, Tokyo is multi-cored—like Los Angeles—and each of these centers (Asakusa, Ueno, Ikebukuro, Ginza, Shibuya, Shinjuku) is separate, yet welded to the texture of the metropolis itself.

Around and among these major nodes spreads the residential city. And here, though we no longer find an imposed and consequently logical pattern—no overall plan in the manner of Pierre-Charles L'Enfant's Washington or Baron Haussmann's Paris—there is much of the natural patterning which is to be discovered in any living organism. The pattern, as many travelers have noticed, is one which seems to have occurred naturally.

An apparent lack of structural logic does not imply chaos. As the social critic Lewis Mumford noted in another context: "Those who refer to the winding streets of . . . a town as mere tracings of the cow path do not realize that the cow's habit of following contours usually produced a more economical and sensible layout . . . than any inflexible system of straight streets." And though Tokyo has few cows, this natural patterning has resulted in something just as sensible.

The pattern of Tokyo is that of a small town, a village—lots of them. Each of these, these cells of living Tokyo, presses against the other—each independent but with near-identical parts. There is the general store or supermarket, the beauty

parlor, the butcher, the coffee shop, the vegetable store, the *pachinko* parlor, the bookshop, and (until recently) the public bath.

These parts are interchangeable, just as in the module-built traditional Japanese house the parts (*tatami* mats, *shoji* and *fusuma* doors) are also interchangeable: your mats fit my rooms and my *pachinko* parlor next door is just like yours. Hundreds of these "module-built" villages make up the metropolis. And all of these serve the residents, which is why Tokyo has so *much* of everything.

This is also why Tokyo presents its kind of wildly various but uniform appearance. It is a mosaic. A view of Tokyo looks like a pointillistic painting, each dot apparently unattached to the other, each building seemingly alone and independent, yet all merging in identifiable forms (villages) and a cohesive whole (Tokyo). Like cells in the body, each grouping contains identical elements, and the resulting pattern is an organized one.

One of the results is that Tokyo life is surprisingly like small-town life. The big-city feeling is missing. There is the anonymity unavoidable when large numbers of people congregate, but the hard-edge aggression is not there. When people remark on how safe Tokyo is—and they always do because it always is—they are remarking on this village-like feeling. And it's not only the capital; all Japanese cities share this quality.

A structure this organic, this "illogical," extracts a certain price, however, as the logical visitor soon learns. Most of Tokyo's streets are not named, though important corners (village crossroads) are. Plots are not numbered, though finished houses are, with the result that addresses have been assigned in order of construction rather than by location. Though Tokyo resembles, with its web of villages, say London, the capital of Great Britain does not usually insist upon the visitor's going to the mailman, policeman, or local tofu-maker for help in locating an address.

Thus, among the many charms of Tokyo there is not only the novelty of living a small-town life in the largest city in the world, there is also the charm of the unexpected. The city no longer has a plan, and the streets wind as they will, emerge as they are able, stop as they must. The wanderer often becomes gloriously lost.

There are some, to be sure, who do not find this charming. Among them would be that early traveler John La Farge, who in 1886 wrote of Tokyo as "this big, dreary city of innumerable little houses"; and, a century later, the Japanese novelist Kobo Abe, who commented that the number of villages did indeed appear "limitless" and that in addition "the villages and their people all appear identical. So, no matter how far you walk you seem to remain where you started, going nowhere at all."

Much of the charm of Tokyo, then, is the charm of the disconcerting. If you want to be constantly reassured, then you should go to Kyoto or Kanazawa, places one masters with a map and a free afternoon.

Tokyo can also be unnerving. For example, the building that always told you where you were in particularly mercurial Ikebukuro suddenly disappears, replaced by a hole in the ground, replaced, a month later, by an entirely new, entirely different structure.

This rapid rate of growth, this visible decline and regeneration, though at times unnerving, is also natural in the way

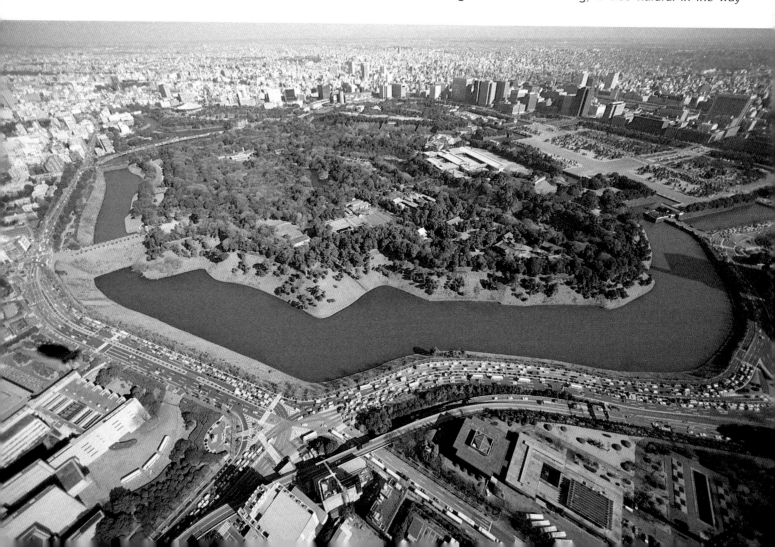

that life in any self-renewing landscape is natural—as J. M. Richards perceived, though perhaps not intending a compliment, when he wrote that "the Japanese, having totally tamed their country, deliberately kept their jungle in the cities." What has occurred is that the Japanese have subverted the fine and orderly plans of their cities. The center of Kyoto, for example, may be laid out in a grand Chinese-inspired grid, but once out of it, Japan takes over in the alleys and warrens of the surrounding city.

In these unlikely attributes, a random structure and an amazing rate of attrition, we find another of the charms of Tokyo—its equally amazing dynamism. The city is alive as are few others. It grows, changes, metamorphoses according to laws of its own. In so doing it satisfies one of mankind's deepest cravings—the need for permanent change.

Life—man and his monuments—may be immortalized, as are the pyramids of Egypt; or they may be eternally renewed, as are the shrines of Ise, torn down and precisely reconstructed every two decades; or they may be allowed to evanesce. This last is Tokyo's way. Like Heraclitus' river, this city is always different and always the same, a deeply satisfying combination. Like Rome, Tokyo is a city of layers. But this is not the Eternal City—it is instead the Evanescent Capital.

Such qualities, temporal and spatial, affect the Tokyo dweller. Living with constant change makes one more open, more curious. The constant stimulation of the city makes one more active. The very anonymity of the largest city in the world creates a paradoxical but very real freedom.

And since a city thrives on energy, Tokyo people tend to be frenetic, always rushing hither and thither, their lives an opposite to some presumed reposeful Japanese ideal. If one finds energy attractive, then this quality is also one of the major charms of Tokyo.

There is, to be sure, the questionable end to which this energy is largely directed. The early traveler Isabella Bird offered an insight as valid today as in 1880: As for Japan, "a bald materialism [is] its highest creed and material gain its goal."

But boredom—whatever else—need not be encountered in this galvanized metropolis. What Dr. Johnson once said of London may now be said of Tokyo. It has "a wonderful immensity," it "comprehends the whole of human life," and "the man who is tired of [it] is tired of life."

Since one never knows what to expect in Tokyo, one remains alert. This quality is indeed associated with the people of the capital. They may seem (in the subway or train) not to be, yet an inner alertness and a need to keep busy all the time, even while resting (hence the popularity of *pachinko*), creates a folk designed to cope with the charming and metamorphosing monster inside which they live.

They also, understandably, get more tired than do other Japanese. As the artist Tadanori Yokoo has said: "When I walk through the streets of Tokyo, it is not unusual for me to weave back and forth as if I were recovering from an illness." There is nothing wearier-looking than a weary Tokyoite. Alertness temporarily suppressed, he falls asleep on the subway, even slumbers standing up, yet manages to stumble out at his stop.

He is also—a quality akin to repose, rest, even sleeping—given to nostalgia. This is because Tokyo's permanent impermanence makes it a poignant place. So much of what one remembers (from last year, or last month, or last week)

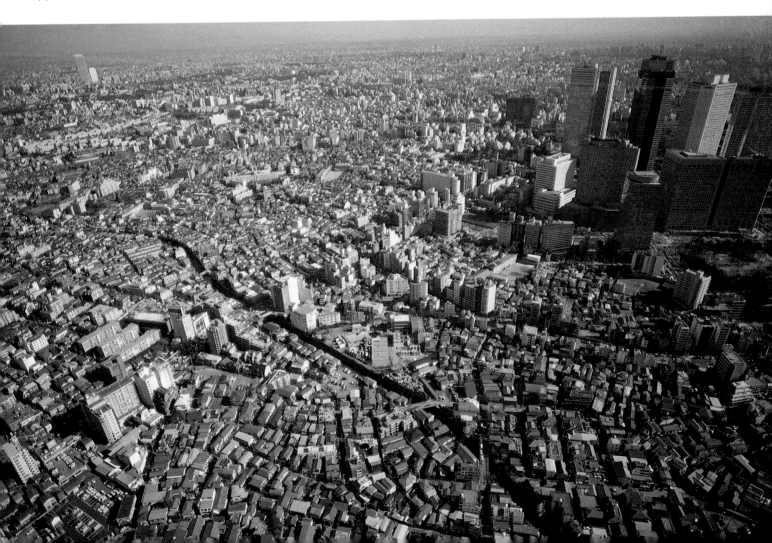

is now gone. The Forum in Rome does not, whatever else, call up a nostalgia. It will always, battered though it be, proclaim itself. How different, say, from Tokyo Onsen, the Ginza's largest bathhouse, a venerable forty years old, now all glass and chrome and requiring a mandatory pair of blue panties to be worn while bathing. There are many who, with a sigh, remember the good old place.

In this respect one of Tokyo's most typical citizens was the novelist Kafu Nagai, a man who continually lamented change and always celebrated poignancy. He remembered a bit of the old Edo-period city and (the quote is from an early story) "could not bring himself into harmony with the vulgar clutter of Meiji." This dislike of the bustling turn-of-the-century life was tempered when, in the midst of the messy Taisho period (the 1920s), he is to be seen regretting Meiji. Toward the end of his life, in sprawling Showa (the present era), he would regret a tidier Taisho. But through it all he remained a typically active and inquisitive Tokyoite.

Certainly the gentle charm of nostalgia is not possible unless whatever is regretted has already slipped almost entirely from sight. It is then that a fabled past asserts itself and stagnant backwaters are searched out and admired.

Tokyo still contains a few of these. Sections of Asakusa have not entirely succumbed to the new, though a deliberate policy of Williamsburg-like gentrification is now taking place. The area above Ueno still contains a late-Taisho feeling, and early Showa "remains" are found in Yanaka, around Nezu up in Sendagi.

Not for long, to be sure. Nostalgia is an uneconomical emotion and, though prized, is—like the famous old tree on the proposed site for a highrise condominium—the first thing to go. Considerations other than history, culture, beauty, and nature always win, and the bulldozer is invariably called.

If Japan is the land of contrasts it so often advertises itself as being, then Tokyo is a distillation of that quality. Sold to modernity, it yet feels mildly nostalgic about its relics; fond of the "new," it lives comfortably in its nameless old warrens; given to a fierce work ethic, it is nonetheless the most hedonistic, the most frivolously play-filled of the world's great capitals.

The people of Tokyo, conditioned by all these various pressures, galvanized by this alternating current, have within themselves the contradictions of their great city. They are curious, friendly, gregarious, lonely, suspicious, rude, polite, and very human—they are really the main view, the true charm of this whole wonderfully monstrous capital, Tokyo.

Tokyo—where the priest times his early morning temple bell by the tone broadcast over his transistor radio, where the festival dragon and the everyday auto lie down together, where the information-packed city view looks like an enlarged microchip, where the sprawling metropolis remains a cluster of simple villages, and where mighty skyscrapers are built on land that still quakes.

If, as has been said, "a city is the face wherein a nation's character may be read," then one is admiring all of Japan (Hearn to the contrary) when one admires the ever-changing but changeless human pattern that is Tokyo. Here the floating world remains visible still, its myriad patterns clearly to be seen, its charm persisting yet.

Donald Richie
Tokyo, Japan

The Imperial Palace and Grounds

The Imperial Palace and its grounds marked the historical beginnings of the capital and they still indicate its geographical center. Today, though otherwise as reticulated as Los Angeles, Tokyo retains this core. As Roland Barthes has noticed, however, though Tokyo "does possess a center . . . this center is empty."

"Empty" means not filled in with city. For in the middle of one of the world's largest cities is this island of green, 280 acres (110 hectares) of it, said to re-

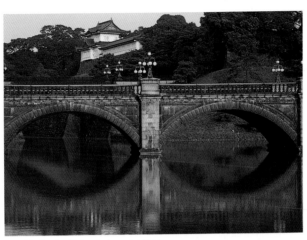

The Nijubashi, Tokyo's Imperial Bridge.

main the home of rabbits and pheasants still, and containing otherwise only the palace, the adjacent buildings, and those who live and work there.

This closed and moated domain is approachable by the public only two days of the year, January 2 and April 29, when the emperor and the imperial family appear on the palace balcony to receive from the assembled thousands New Year's and birthday felicitations.

There are, however, whole sections of the palace grounds where the public may enter. One is Kitanomaru Park, formerly home to the imperial guard and now containing a number of museums and gardens, as well as the Budokan, that enormous hall originally designed for *budo*, or martial arts, and now used for everything from judo to rock concerts.

Another section now open to the public is the Kokyo Higashi Gyoen—the Eastern Garden. The sheer power of the castle may still be experienced here if you enter the garden through the Kitahanebashi Gate. You will find yourself in a stone-walled square facing yet another massive gate. This space was designed as a trap to any who had breached the initial gate. And, beyond, a further baffle of stone walls confused any who got beyond the second. Originally these mazes led to the central castle but now only the original platform remains, and the citadel itself has been reduced to a guard box.

The original palace had ninety-nine gates, twenty-one large watchtowers (three still standing), and twenty-eight storehouses for munitions. Its outer defenses were extensive, stretching from modern Shinbashi Station to Kanda, with the castle grounds proper pushing beyond where Tokyo Station now stands. It was, with its miles of corridors, its multitude of halls and chambers, its courts and keeps, the largest castle in the world.

Something more of the ancient romance can be glimpsed from outside, the single "view," that from the Kokyo Gaien, the Imperial Palace Plaza. From this wide expanse with its pines and raked gravel, we can get a feel for what the medieval castle must have looked like. Here is the Nijubashi and behind it what appears to be the palace. Actually we are looking at two fairly modern bridges, and the structure behind is not a part of the palace. It is Fushimi Tower, one of the few original castle buildings left, dating from the first half of the seventeenth century.

Also redolent of the power of this once mighty fortress-castle are the walls of the inner moat, those seen when one walks around the palace. These are made of great slabs of stone quarried in distant Izu. Though the Edo port was much nearer the castle than Tokyo's is now, some of the rocks still required teams of a hundred or more men to haul them. Often they had to be loaded onto sledges, with seaweed laid along the path to ease their progress. Once at the site the stones were chiseled into shape to fit precisely. It is said that the original fit was so exact not even a knife blade could be inserted between the dressed stones. Even now wind and rain fail to penetrate the cracks, and the weather does not pock these cyclopean walls.

Behind them live the emperor and his family in the Fukiage Gosho, a fairly new palace built in 1961. It covers over a thousand square yards and contains an imperial bedroom of over twenty *tatami* mats in size, as well as the Chamber of the Pine Tree, a kind of best parlor where ambassadors are met and important guests are entertained.

Not far away sits that other palace of power, the Diet, Japan's parliament and place of the head of the government. This Western-style edifice, modeled after the statehouses of Europe and completed in 1936, contains both the House of Councillors (on the right as you enter) and the House of Representatives (on the left). Also in the neighborhood are the other major "control centers"—the Supreme Court, the Ministry of Justice, the Metropolitan Police Quarters, various other ministries, and so on.

Ancient power, the palace, walled and moated, thus faces modern power, avenued and fenced, in the middle of Tokyo. The empty center still controls the city.

12

Below The imperial moat, looking north. On the left, a palace tower, one of the few remaining structures from the time of Edo Castle; on the right, the towers of the Marunouchi district, including the headquarters of some of Japan's most powerful corporations. *Right* The tower projected (by telephoto lens) against one of the facades of modern Tokyo.

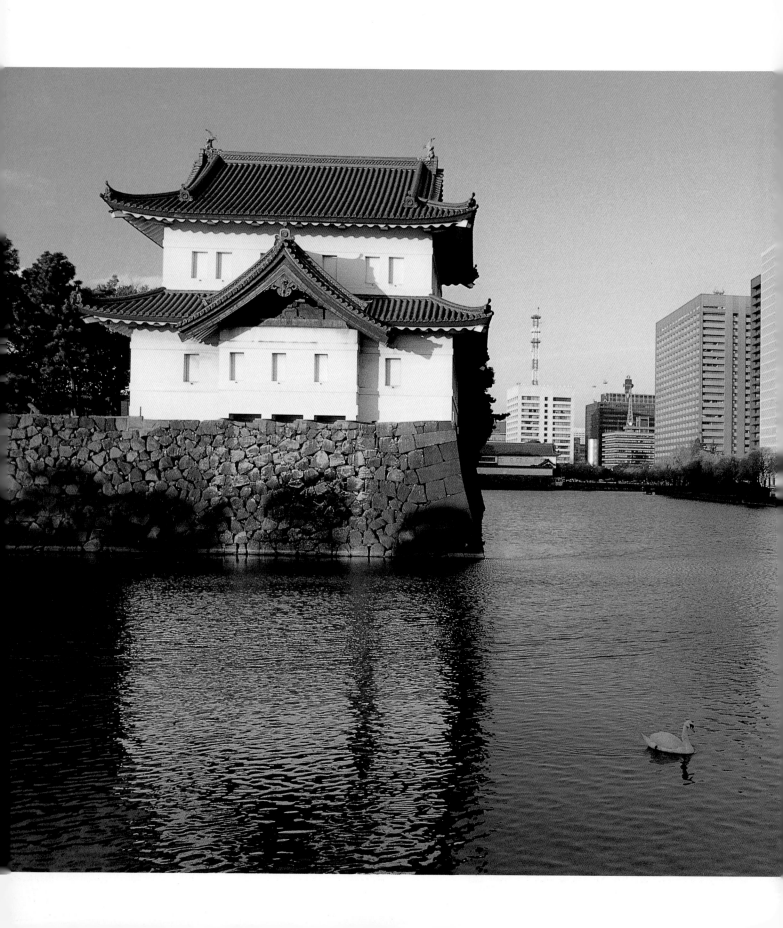

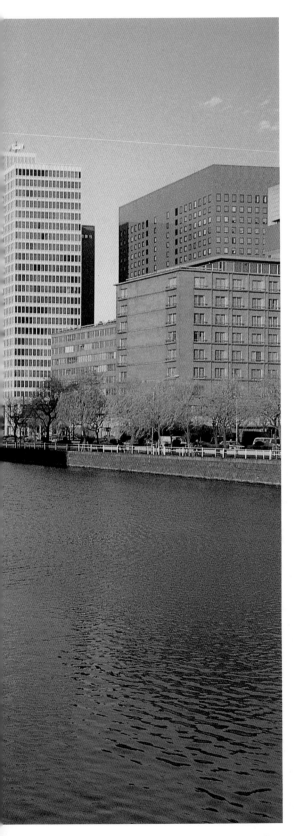

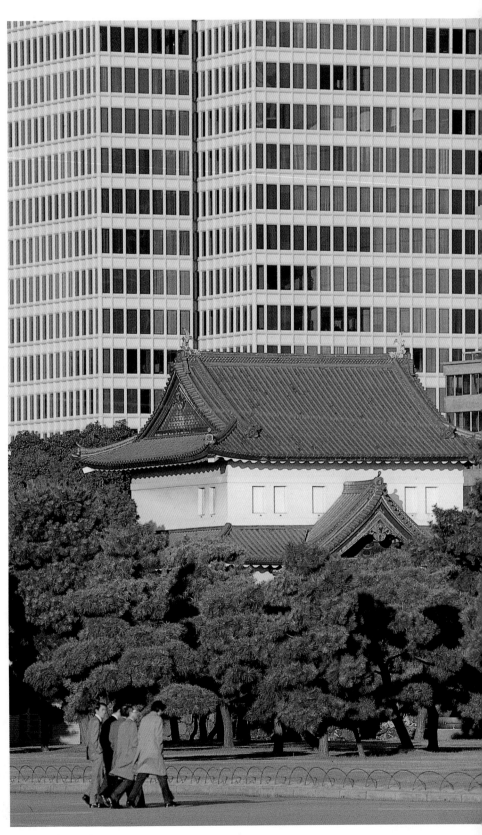

Top The Diet Building, a favorite venue for school-excursion photographs. *Left* Two students beside a reminder of the imperial past. *Center* Expressways now race over the once impregnable walls of the imperial moat at Takebashi. *Right* Two patrons during intermission at the National Theater, located across from the western section of the moat.

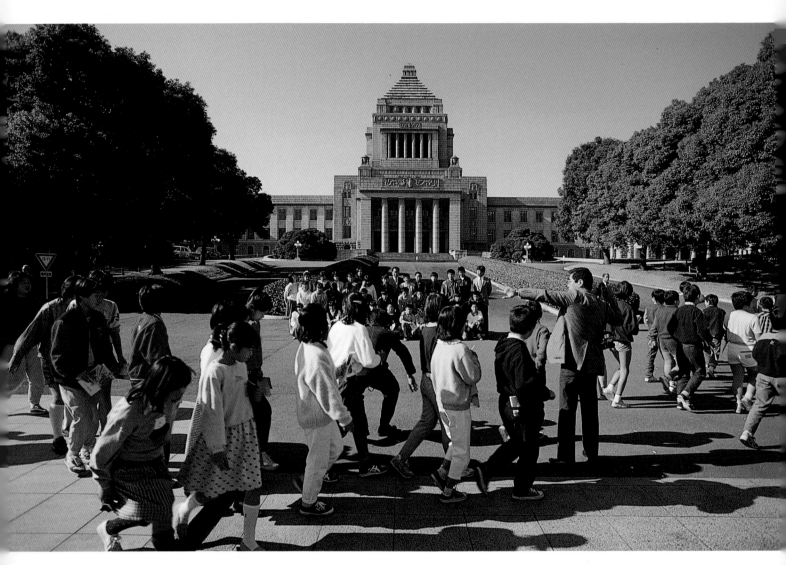

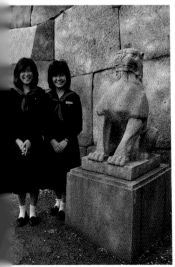

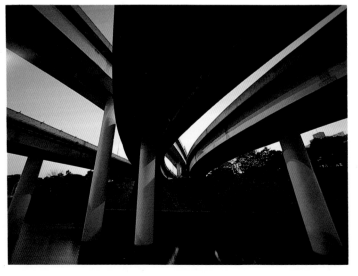

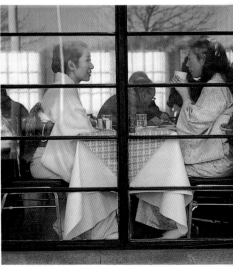

2

From Otemachi, Ochanomizu, Kanda, and Nihonbashi to Akihabara, Ueno, and Asakusa

In the days of the shogunate there was, just inside the Ote Gate, an office where the government's financial concerns were tended to. The location seems fitting, for now that very gate opens onto Otemachi, the place where the major banks and the head offices of many corporations are located. Here, within the shadow of ancient power, big-business Japan makes its home in the capital.

To the north is Kanda, home of universities where, in the words of one Meiji-period statesman, "the coming leaders of Japan receive their proper training." Though land prices in central Tokyo have tempted a number of these institutions to sell and locate anew in the suburbs, there are still quite a number in Kanda and neighboring Ochanomizu. There are also, consequently, more bookstores here than anywhere else in the capital. Lining Kanda's main avenue, Yasukuni-dori, are dozens of shops where books new and used, common and rare, and in all languages are to be found.

Just east of Otemachi is the major mercantile center of old Edo, Nihonbashi. This was the Edo township, the official center of the city, so decreed by the seventeenth-century shogun Tokugawa Ieyasu. All sections of both the city and the country were measured in terms of the distance from the bridge which gives the district its name—Nihonbashi, the Bridge of Japan.

The bridge is there still, a later version of it, now all but obscured by the elevated highway that runs above it. Here, too, was the great Edo fish market (now in Tsukiji) and the local emporiums which later became Tokyo's (and Japan's) major department stores. Here, too (now also gone), were the rice warehouses and the great greengrocers' market famous for its radishes, melons, tangerines.

Another market, just as bright and just as famous, now exists north of Nihonbashi. This is Akihabara, the so-called electric city where there are, according to some estimates, upwards of six hundred shops of all sizes, all dealing in electrical goods of one sort or another. It is an entire town of audio goods, computers, home appliances, integrated circuits, and various electronic "nuts and bolts."

Farther up Chuo-dori (that northern continuation of the Ginza) is another great market. This is the Ameya Yoko-cho district of Ueno, centered in the alley parallel to Chuo-dori

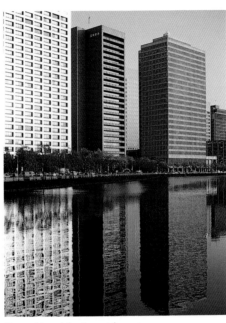
Otemachi and the imperial moat.

and just across from the station. Here the goods are edible: seaweed, squid, dried fish, nuts, fruit of all kinds—a big, ebullient market complete with jostling crowds and shouting hawkers and an almost un-Japanese amount of gusto.

All the noise and fellowship is occasioned, one is told, by a certain kind of Tokyoite, the *edokko*, or "child of Edo," who still lives and thrives here in the *shitamachi* (the "low city," the East End) of the capital. Invariably in the mercantile trades, this archetypal character is hardworking but prodigal in spending, equally hardheaded but sentimental to a fault, fast to anger but first to laugh about it, and always noisy. Whether any such still exist (or ever did), the *edokko* remains an ideal, and the people of the low city still emulate him, even to the extent of cultivating a *shitamachi* accent.

Decorum is regained in other sections of Ueno. In Ueno Park, Tokyo's largest, are some of the last remaining Edo-period buildings (the Toshogu, the Kaneiji Kiyomizu-do), the Ueno Zoo (with its famed pandas), and some of Japan's finest museums. These include the Tokyo National Museum, the Tokyo Metropolitan Art Museum, the National Museum of Western Art, and others, not the least of which is the Shitamachi Museum, devoted exclusively to the low city itself.

This low city continues in Asakusa, once the site of the famed "floating world," the pleasure quarters of old Edo. Here the imposing Kaminari-mon (Thunder Gate) marks the entrance to the Edo-like shopping street known as Nakamise-dori, which leads to the mighty Sensoji, the Asakusa Kannon Temple, around which a few remaining Edo buildings still cling. Though the Kannon Temple has been reconstructed, these have not—they have been merely relocated and offer the traveler a rare glimpse of what he or she perhaps thought Japan ought to look like.

Here, indeed, the past is still with us, particularly on the festival days of the Sanja Matsuri, when the streets of Asakusa are again bursting with noise and laughter. The ancient carnival feeling, reminding one of other cities, other pasts, still continues, palpable. Many have felt it, including city critic Mark Girouard, who wrote, "If one wants to get any feel of what Montmartre was like in the 1890s, one is more likely to do so in Asakusa." It is the last of the old.

Below An avenue in the Marunouchi district, once home of the great lords, now home of the great corporations. *Center* The offices of the Marunouchi at night; white-collar workers on their way to the office; the moat and the buildings of Otemachi—modern Japan.

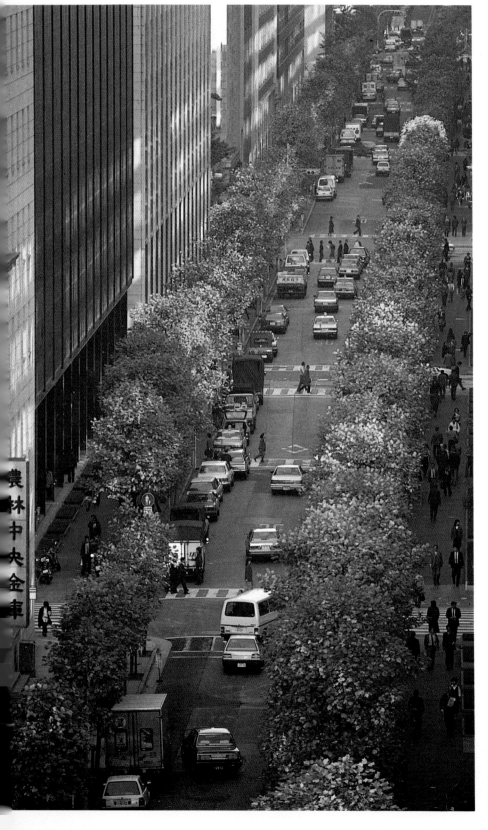

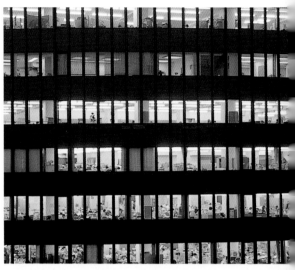

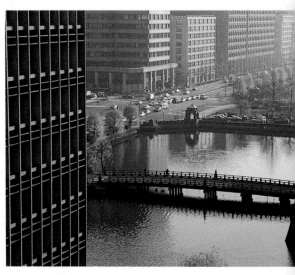

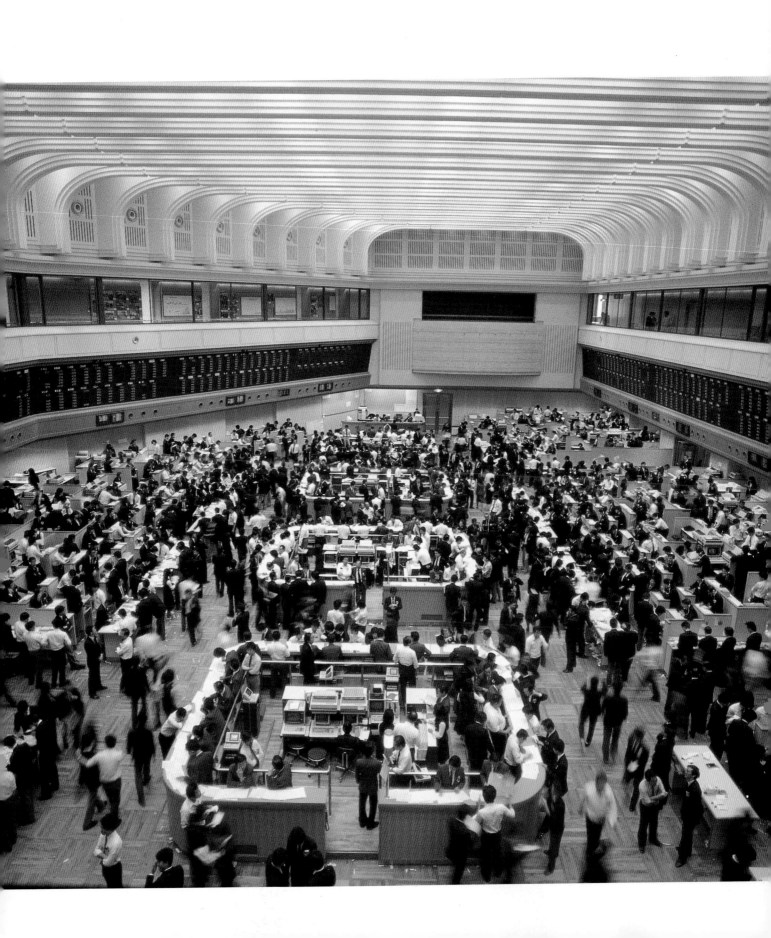

Below The interior of the new stock exchange at Kabutocho, where the nation's business is conducted with computers, telephones, and a whole vocabulary of hand gestures.

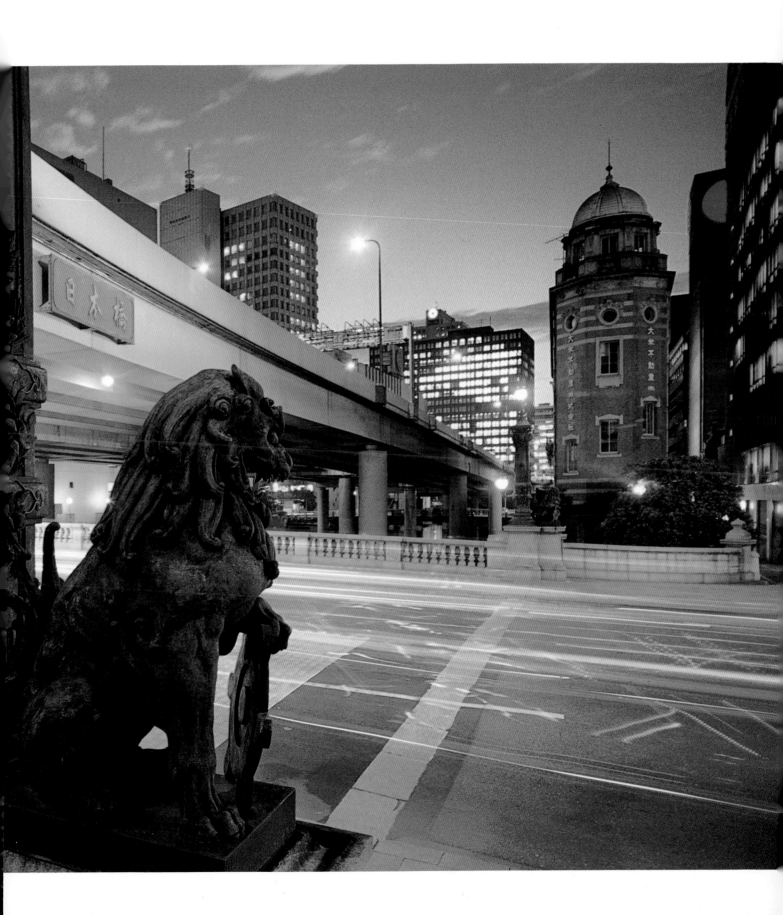

Left A gloved doorman at a corporate building opens a limousine door. *Below* The celebrated Nihonbashi, Bridge of Japan, the point from which all distances in the country were measured. Though reconstructed in 1911 and decorated with lions and unicorns, it is now overshadowed by one of the many expressways erected at the time of the Tokyo Olympics in 1964. Underneath, however, still flows that channeled stream, the Nihonbashi River.

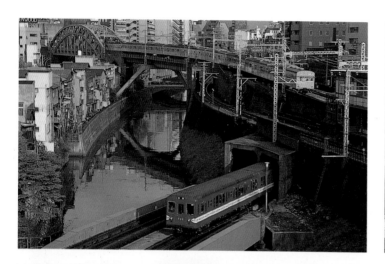

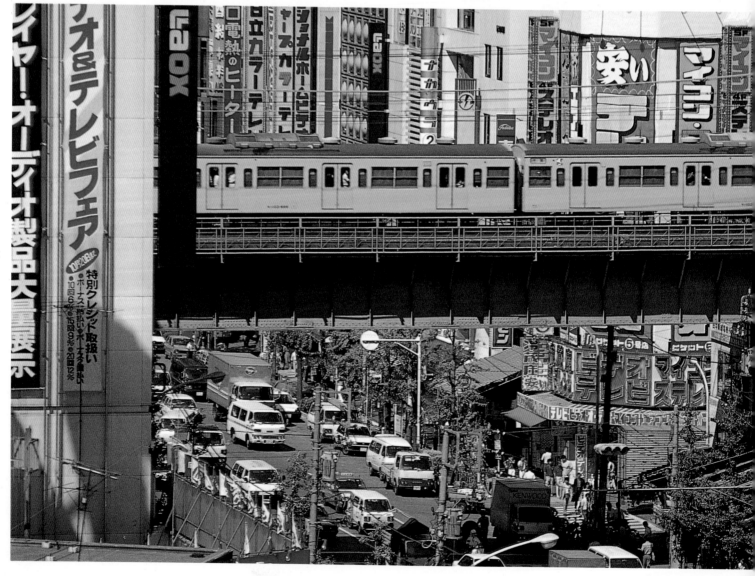

Left Ochanomizu, where the red Marunouchi Subway Line, emerging for a brief stretch, runs under the yellow Sobu Line; a Kanda bookseller; neon and day-glo advertising video, televisions, and computers. The Sobu Line passing through Akihabara, the largest accumulation of electronic outlets in the world. *Below* In front of yet another new outlet stand three sales personnel, the sign above proclaiming BIG OPEN.

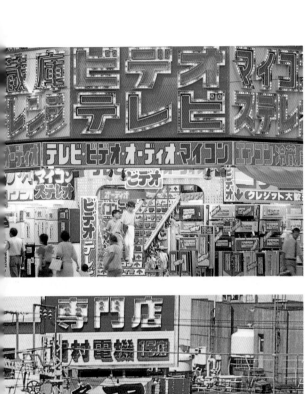

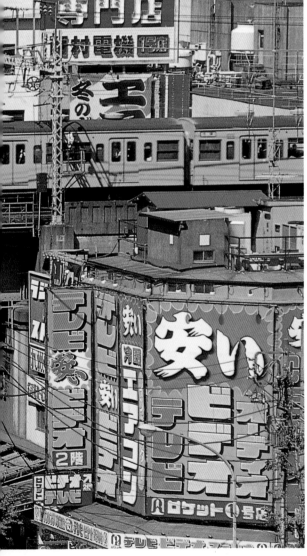

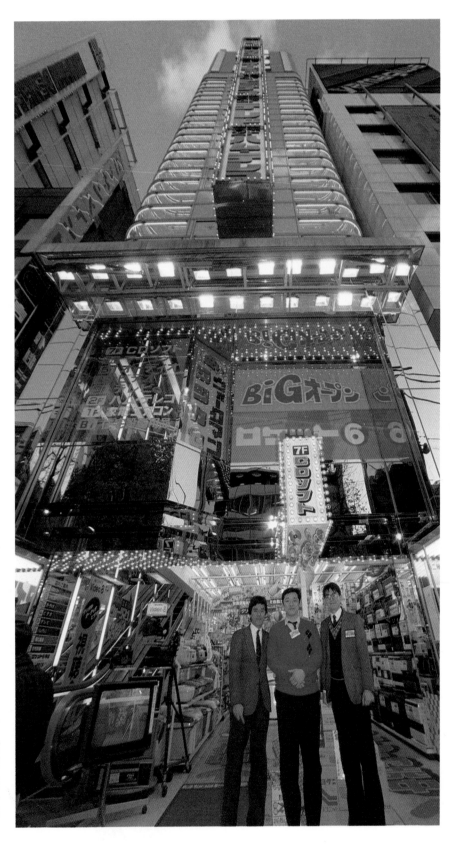

Below One of the museum complexes of Ueno: in the center is the Tokyo National Museum, housing the finest of all collections of Japanese art; on the left, the Hyokeikan, devoted to archaeology; on the right, the Toyokan, holding works from other Asian countries. Top right The Hyokeikan, a 1909 Meiji-period building. Bottom The Hanazono Inari Shrine in Ueno; a couple and their athletic child in front of the elephants at the nearby Ueno Zoo.

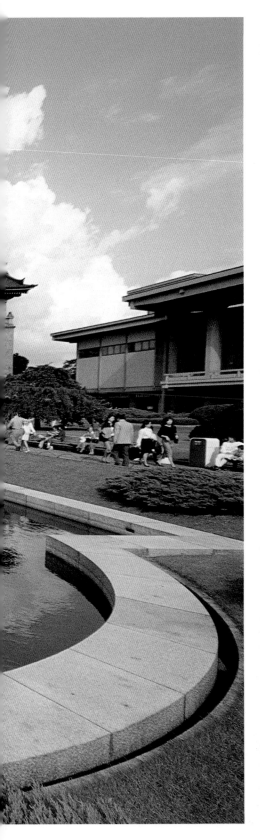

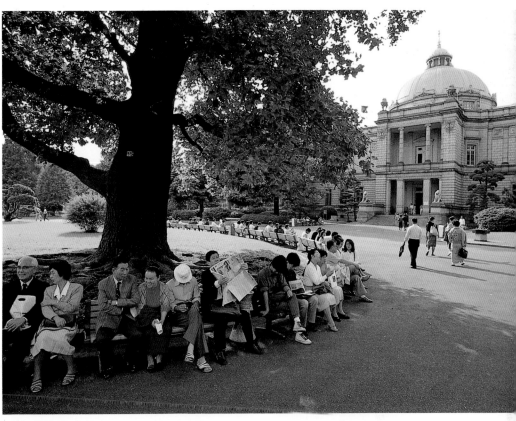

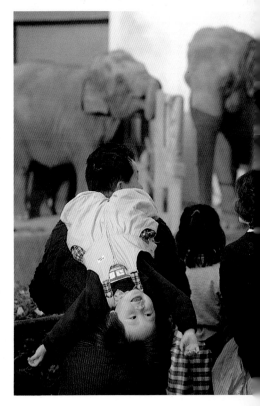

Top Tokyoites enjoying the April cherry blossoms in Ueno Park. *Bottom* Ueno's Ameya Yoko-cho, one of the great downtown markets; *edokko* intent on selling "soft dried squid."

Right In the shadow of the Asakusa Kannon Temple (Sensoji), with the gate in the background, is the famed incense burner—the goddess Kannon is said to cure afflictions if smoke is rubbed on the appropriate part of the body.

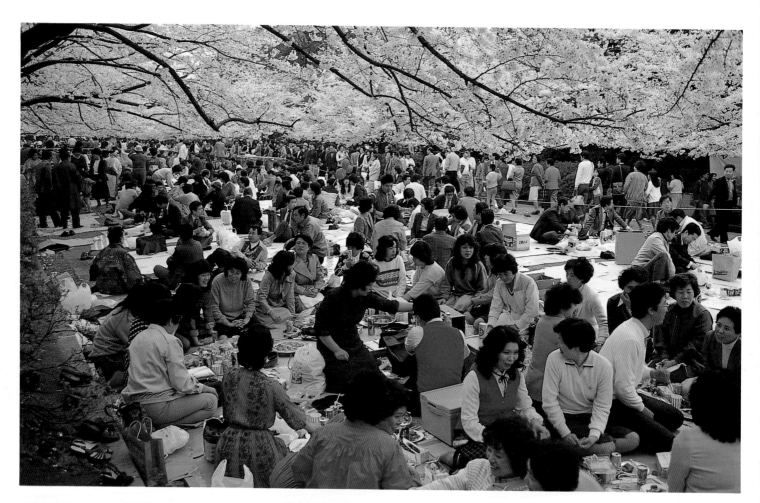

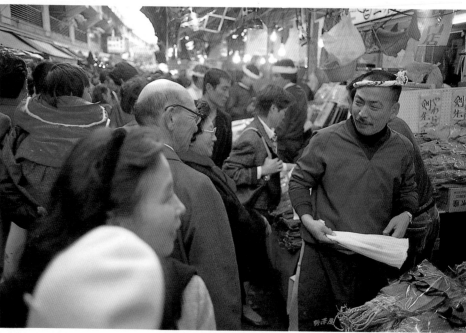

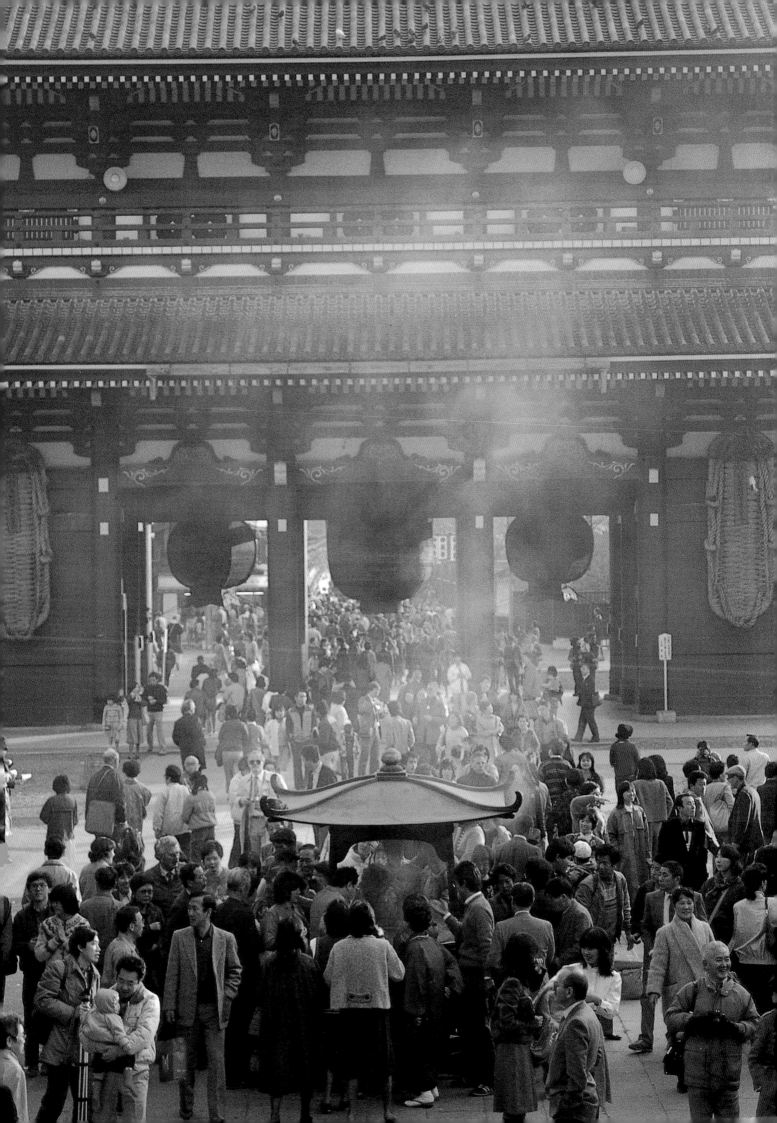

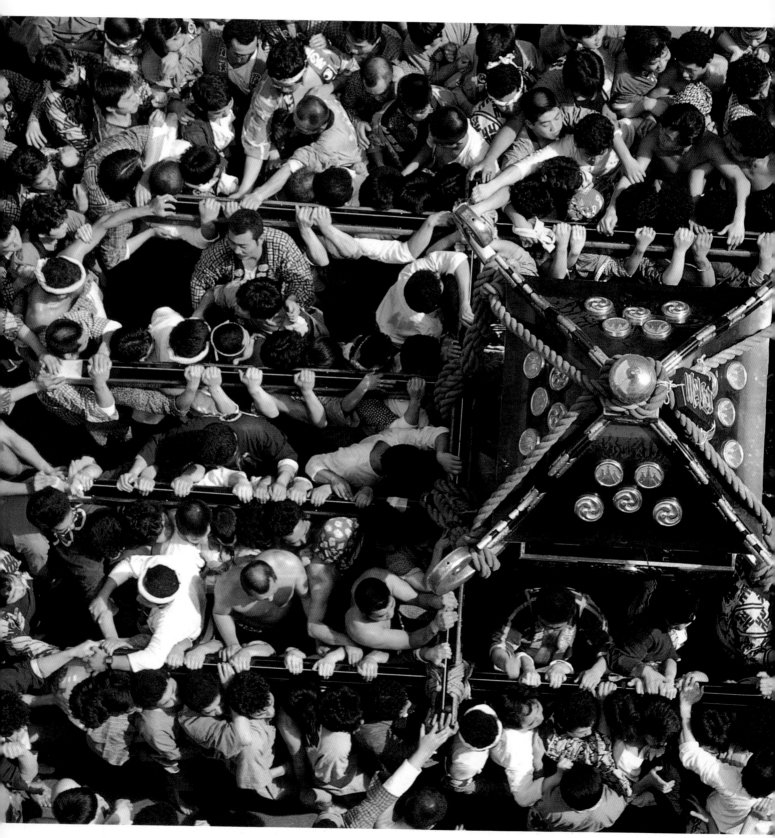

The Sanja Matsuri, one of the great Tokyo annual festivals. Occurring in mid-May, it centers around a grand procession of portable shrines (*o-mikoshi*), each supported by dozens of young men and, nowadays, young women. It is said the god in the shrine much enjoys being jostled about. Here are echoes of old Edo, its noise, its movement, its complete vitality.

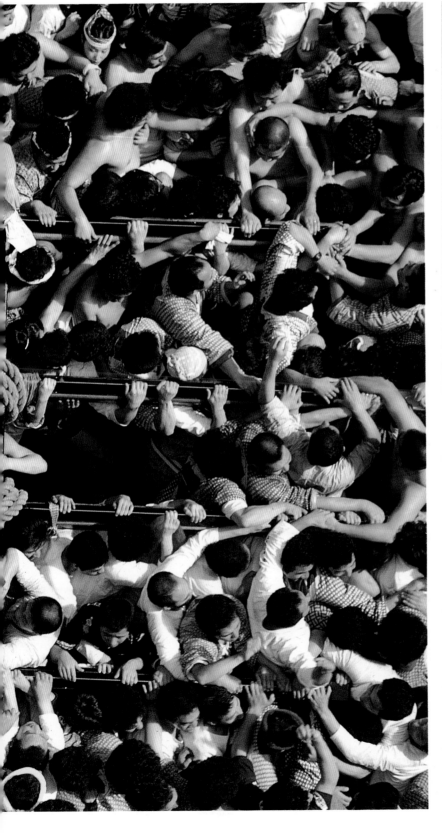

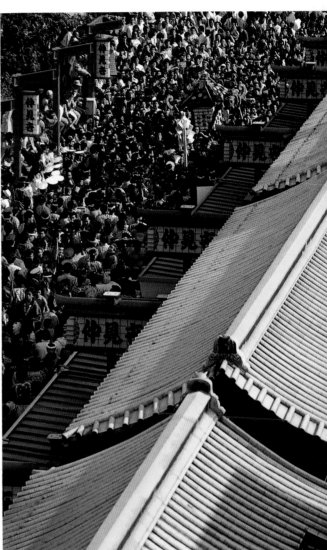

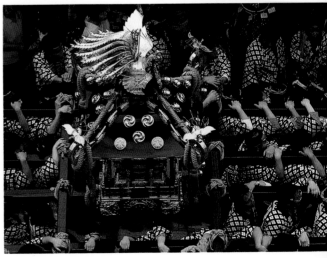

Top left A tourist group poses in front of the Asakusa temple gate, god of wind on the right, of thunder on the left. *Bottom left* One of the temple priests reading sutras, begging-bell in hand. *Top right* Two *okami-san*, proprietresses of local restaurants and drinking establishments. *Bottom right* A typical Asakusa *nomiya* drinking place, festooned with banners for the summer favorite, draft beer.

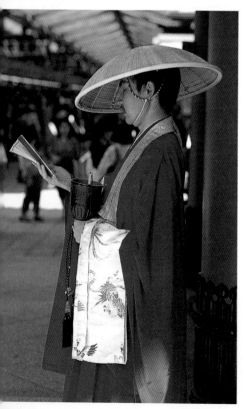

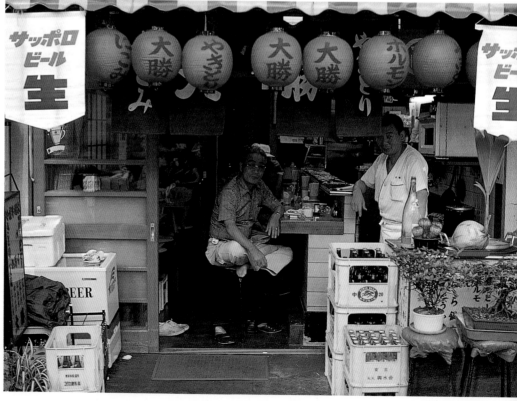

3
The Sumida River, Ryogoku, Tsukiji, and Tokyo Bay

Tokyo has a river, but the Sumida was never to Tokyo as the Arno was to Florence or the Seine to Paris. The city did not grow around the river, nor was the site chosen only because of its proximity. Edo, like Beijing and Washington, D.C., was a city by decree. It was ordained that a city be created there, on the heights before the bay. That a river ran nearby played no truly important part in civic calculations.

Perhaps consequently there was, and remains, a feeling of ambivalence about the Sumida and the lands that hug its banks. *Kawa no muko*, "across the river," meant (indeed, means) the unfashionable, the sticks. The area was used as a place of exile, and when the Edo government decided to rid itself of unsavory elements (whores, pimps, actors), it was over along the river that it sent them—thus creating the Yoshiwara pleasure quarters.

Later, it was along the river that were found the geisha houses and those discreet "teahouses," so often places of assignation. Farther down, the *sumo* wrestlers were lodged in riverbound Fukagawa and, later, the first resident foreigners were put into the elegant ghettos of Tsukiji. All of this along the river and thus removed from both castle and government.

Ironically, these neglected regions were among the city's most pleasant. Early literature is filled with references to boating at dusk on the river, to the great fields of fireflies along its banks, to the pleasant sound of summer insects. Edo was, no matter what the official opinion, a city on and of the water, and the Sumida was its greatest waterway.

Tokyo actually has many lesser waterways, including some several score of rivers, streams, brooks, and many more canals. Most of these, however, are roofed over by expressways or encased in concrete, and few are allowed to surface. As a result, it is only the Sumida (and the canals of Koto Ward) that maintain the city's water aspect. Certainly the river is the only waterway that still has public transportation. A ferry, or "waterbus" (*suijo-basu*), runs from Asakusa to the Hama Rikyu Garden. It affords a glimpse of what is left of the old way of life along the Sumida.

Directly opposite Asakusa is Sumida Park (where the autumn insects once sang), with its fine riverside cherry-tree-lined avenue. Boating down the river from Asakusa, cup of

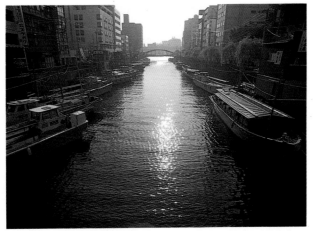

A canal off the Sumida River.

saké in hand, one then sails under the Azumabashi, one of the first of the many bridges to cross the Sumida. And just beyond is where throngs stand in midsummer to watch the amazing Sumida River fireworks display.

Farther down one passes the *sumo* arena in Ryogoku and the four-legged Edo-Tokyo Museum. Nearby, beyond the retaining walls and largely invisible from the river, are the last few houses of Yanagibashi, one of the great geisha districts of the nineteenth-century Meiji period. One must look soon. They will not last long.

Due to the bridges and the embankments there is not much to see of the lower Sumida anymore. Commerce made the bridges, flood-control the embankments, and history got lost in between.

Yet, something of the past remains. The tiny island of Tsukudajima has a bit of the Edo flavor. It was where (Edo's attitude to its waterways being what it was) ex-convicts were rehabilitated. Here, too, gathered the other outcasts: the homeless and the plain poor. Also here was the home of the shogun's marine spies, nominally fishermen. In this conservative atmosphere there were few changes and the place still remains, though for how long is unknown: the city is planning a second cluster of Shinjuku-like skyscrapers, as well as a wholesale fill-in of the delta.

Nearby is Tsukiji, once a part of the bay (the name means "reclaimed land") and now home of Tokyo's largest markets. Among these, by far the most famous is the fish market, which has become one of the local sights, if one arrives early enough, say five A.M.

And farther downriver is the Hama Rikyu Palace (near the pier where the ferry docks), where stayed, among others, Ulysses S. Grant, and where even today remain the lush gardens with their tiered pines and serpentine tidal pool.

Just beyond here the Sumida empties into Tokyo Bay. This great, broad, shallow body of water once boasted sandy beaches and fine clamming grounds, boathouses, and fresh, salubrious breezes. Now it boasts of none of these. Tokyo is slowly reclaiming the bay, and the new land is given over to refineries, apartment blocks, and the like. Tokyo's ambivalence toward its waterways continues.

Below A view of the Sumida River, looking to the northeast toward Fukugawa; in the foreground the Eitaibashi, Bridge of Eternal Ages, reconstructed in 1925 and now the oldest of the Sumida's bridges. *Top right* Mouth of one of the small canals leading off of the Sumida. *Bottom right* Looking upstream toward a recent bridge, the Shin Ohashi.

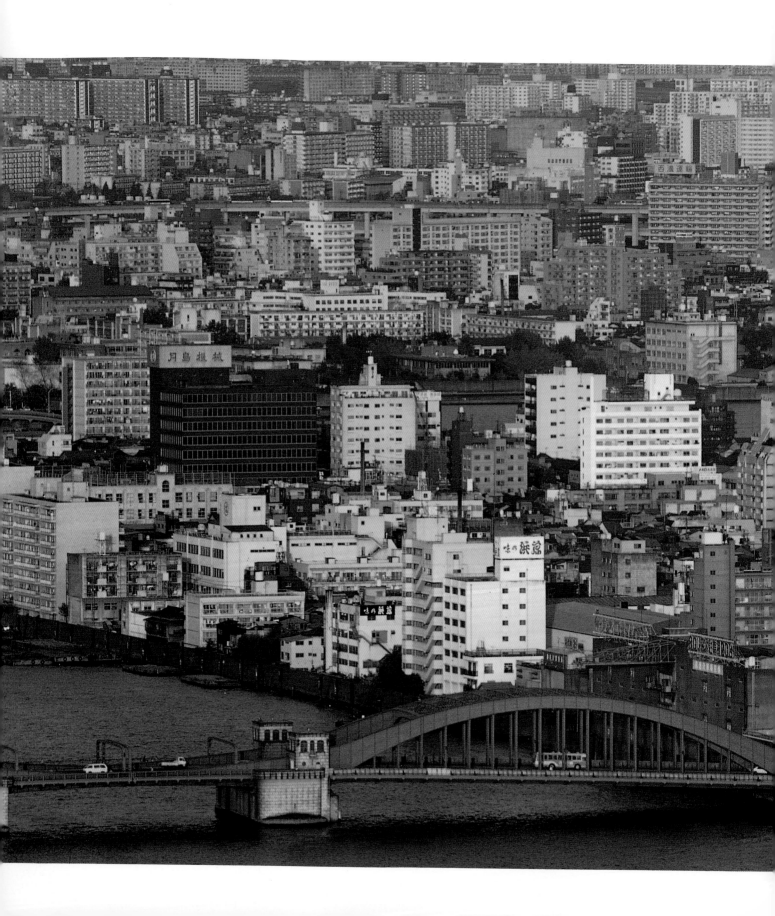

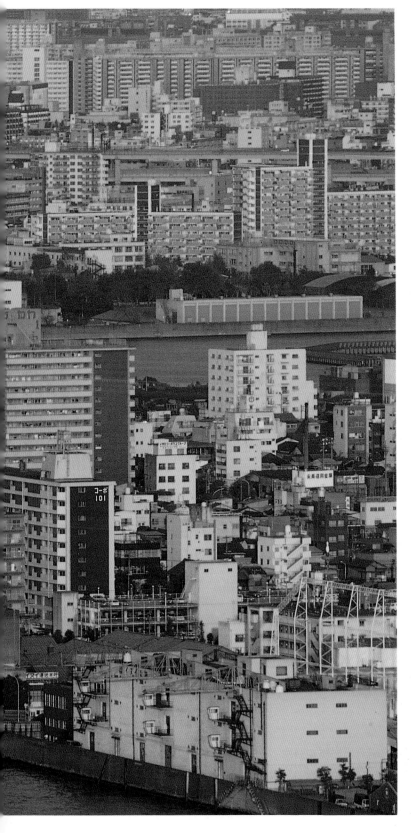

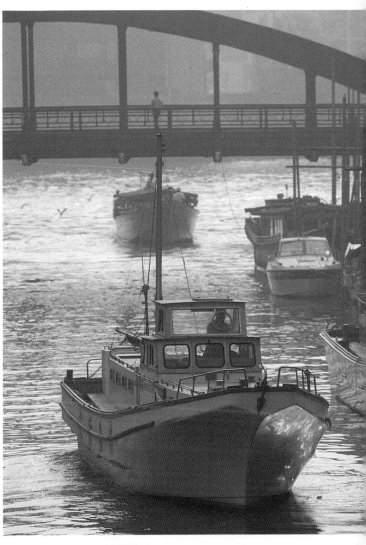

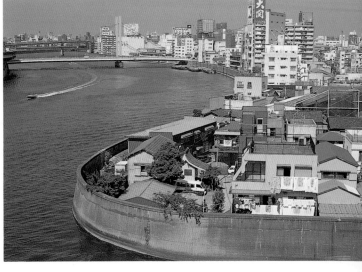

Top left **Banners and drum tower, a part of the** *sumo* **pageantry.** *Bottom left* **Two** *sumo* **wrestlers out for a walk.** *Top right* **Daily practice session, with trousered coach standing near the god-shelf.** *Bottom right* **A** *sumo* **match with traditionally garbed referee.**

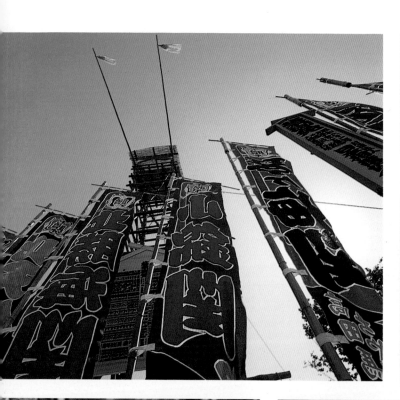

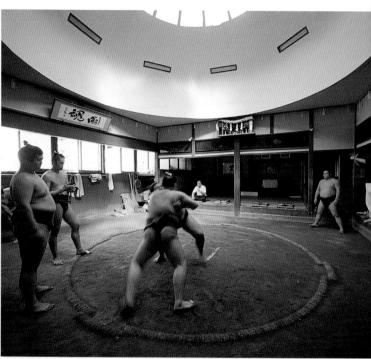

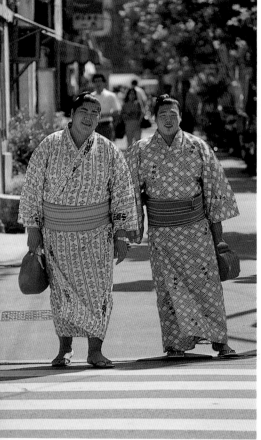

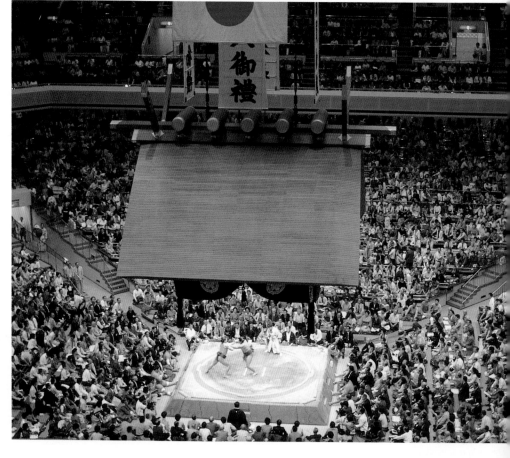

Top Domestic facades in Tsukudajima—traditional architecture and bright red bike. *Bottom* Resident and his azalea collection; downtown azalea gardens and admirers.

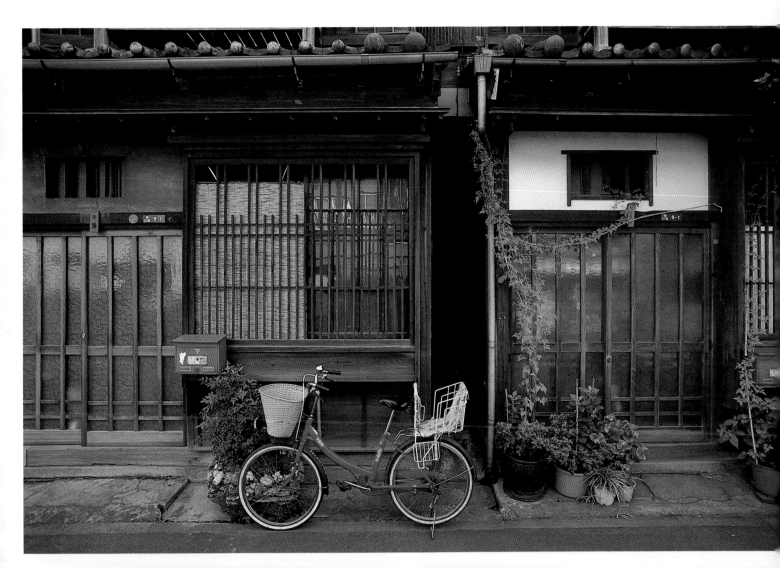

Below Scenes from the Tsukiji fish market, largest in Japan, where the day's catch is auctioned off early in the morning.

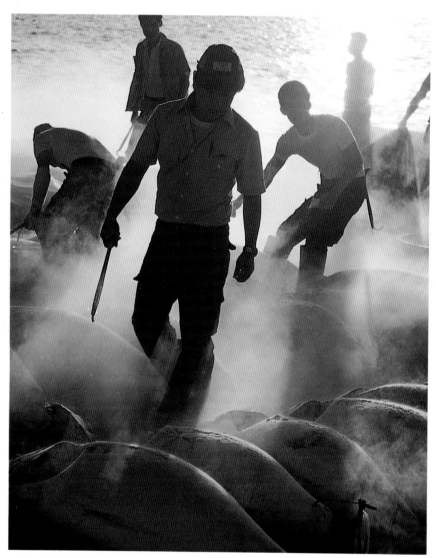

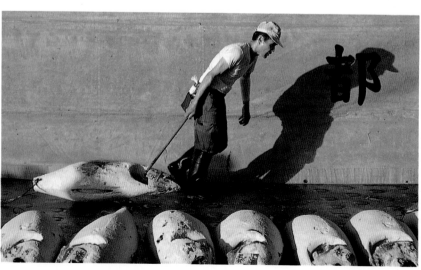

Below Scenes of Tokyo Bay: the warehouses along the docks, and the waterway at night and at daybreak. *Overleaf* Tokyo Bay at dusk, with the city lights just coming on, and the city itself and the towers of Shinjuku in the distant west, still in the early evening light.

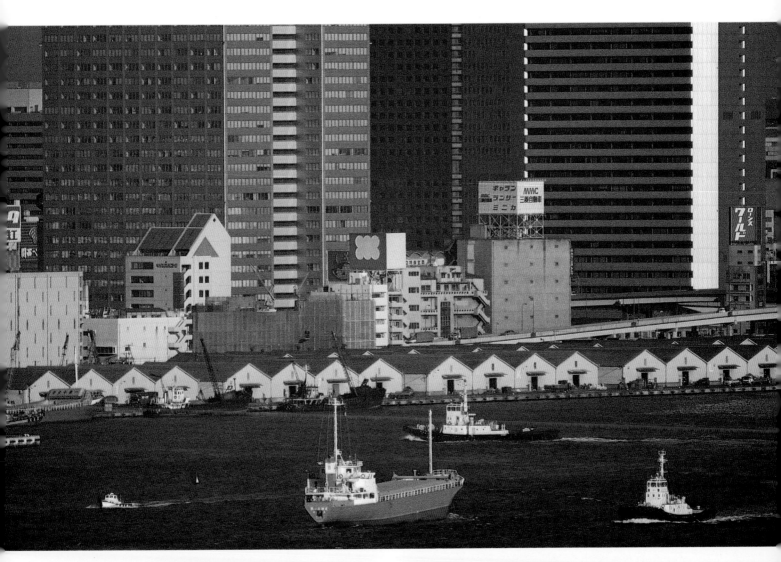

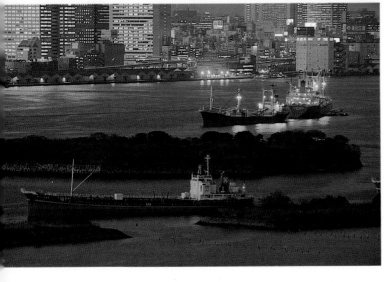

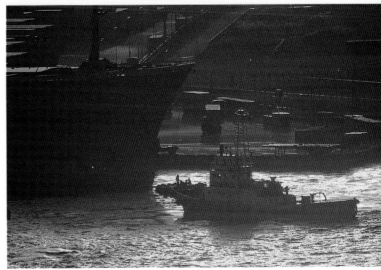

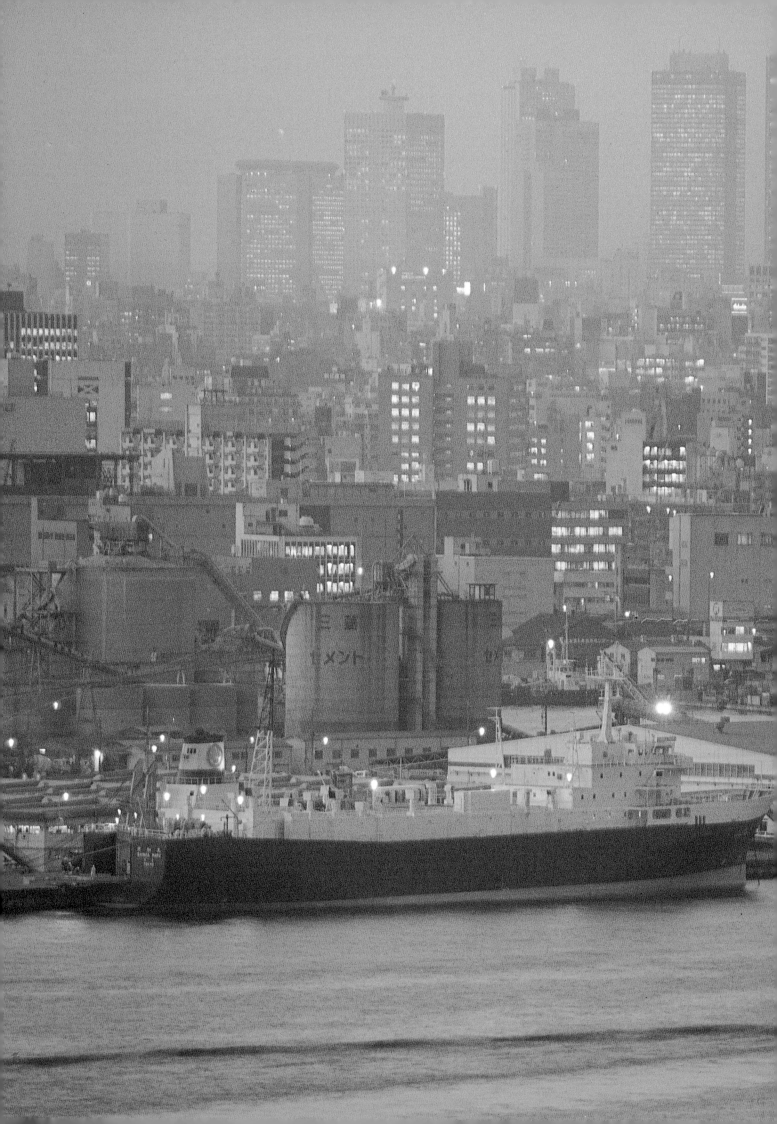

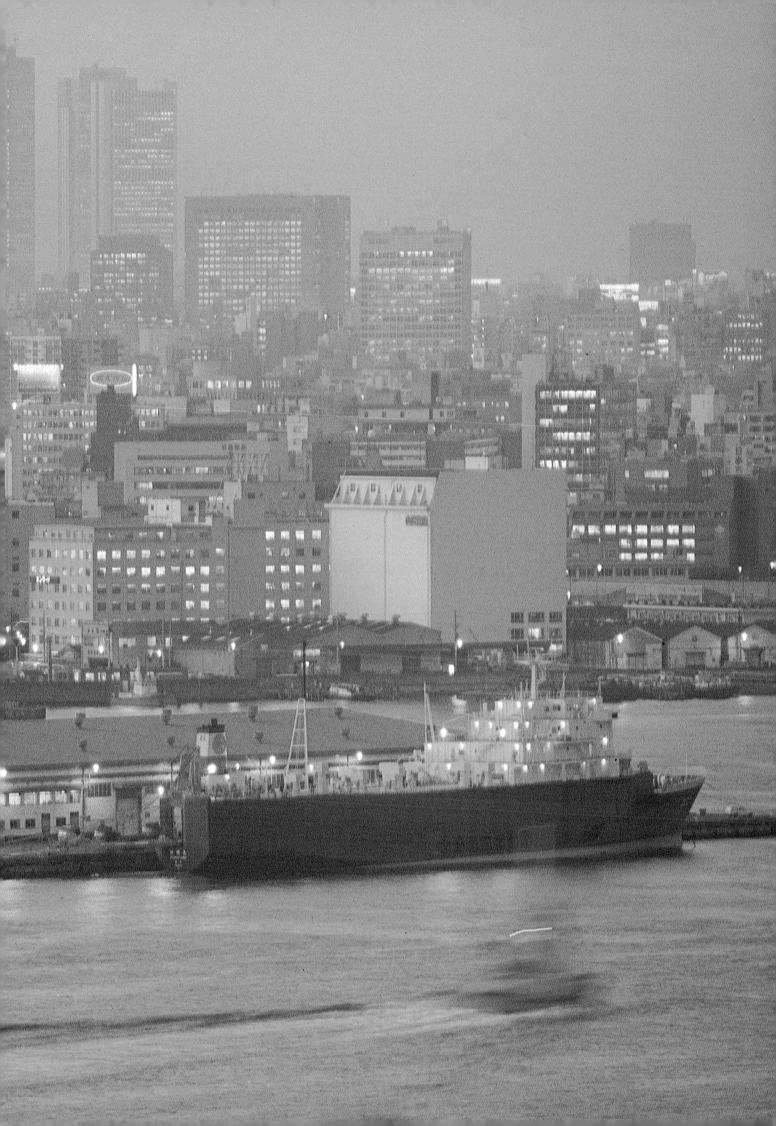

38

Top A government apartment complex (*danchi*), with laundry and *futon* bedding being aired, on Umetatechi, one of the manmade islands in Tokyo Bay. *Bottom* The monorail on its way to Haneda Airport sweeps by on a course parallel to the Keihin Canal; the train yard of the famed bullet trains at Oi Terminal on the bay—the older snub-nosed engines and the elongated new.

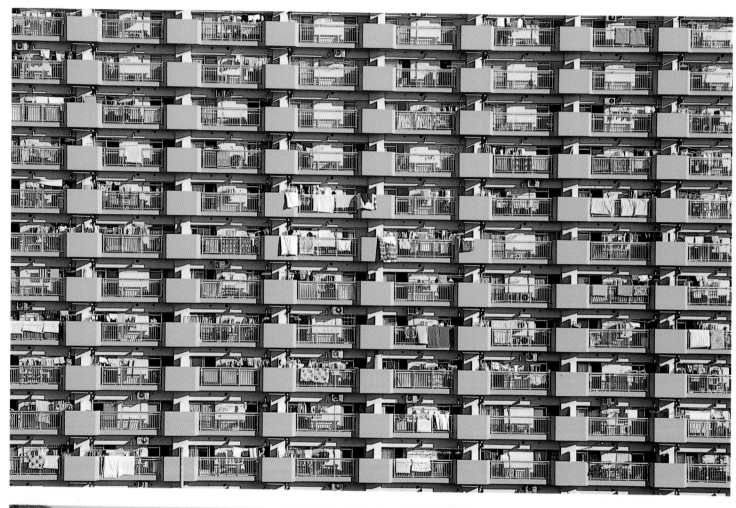

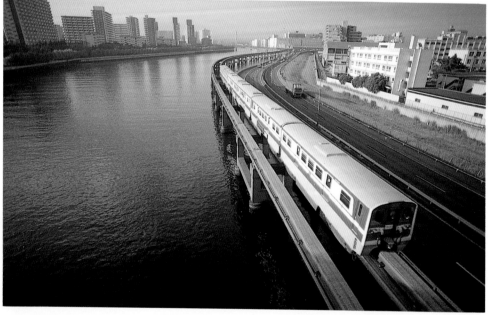

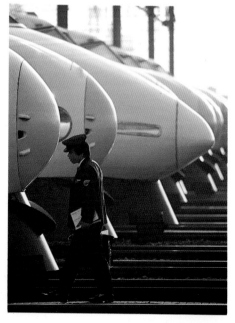

4
The Marunouchi, Tokyo Station, Yurakucho, Hibiya, and the Ginza

The Marunouchi district is the area in front of the Imperial Plaza which extends over to Tokyo Station and down to Yurakucho. The name means "within the wall," indicating that in Edo times the area was considered well inside the outer defense works. Here, where the headquarters of the giants of Japanese industry now stand, were the fine residences of the great feudal lords.

Though modern Tokyo is largely a tangle of streets, alleys,

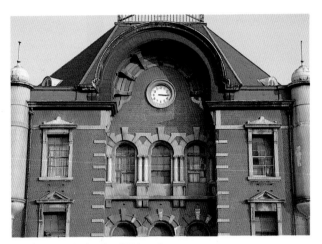

The Marunouchi façade of Tokyo Station.

and warrens, the Marunouchi was designed in orderly right-angled blocks like the model neighborhood it was. Neither streets nor houses, however, survived Japan's first great modernization. With the fall of the shogunate and the rise of the Meiji emperor's era of enlightenment, the entire area was razed and for years lay unused.

Though Otemachi was soon selected as the site for the new Home Ministry and the Treasury Building, and the land that is now Hibiya Park became an enormous military parade ground, the Marunouchi land stood idle. Even after it was bought by the members of the family who had founded the fledgling Mitsubishi company, it remained empty. People called it the Mitsubishi Wasteland. It was not until a late-nineteenth-century building boom that the area was filled—filled with new buildings in a new style. These were all red brick, late Victorian, and, not surprisingly, the area became known as the London Block.

London Block, too, has vanished, except for that late arrival, Tokyo Station, which, for the time being, continues to give some idea of how the area once appeared. It was originally meant to serve not only as a station but also as a memorial to Japan's victory in the Russo-Japanese War (1904–5). The main entrance was at one time reserved exclusively for the imperial family. Nowadays the entrances are used by approximately five times the number of those who daily use Grand Central Station in New York. Some 2,500 trains pass through the station every day. These are reasons that suggest that this venerable and "inefficient" building will be razed sometime in the near future. Then the entire Marunouchi will be in the current style, what one might call Big-Business Modern.

Certainly the adjacent Yurakucho area has become modern enough for any taste—though here, too, as else-

where in Tokyo, the past survives in the odd corner. One such place can be found under the tracks, up from the Imperial Hotel and down from the aggressively modern Mullion Complex. Nameless, this small street of outdoor stalls looks and feels just like 1945 Japan.

The immediate postwar years were Yurakucho's greatest period. MacArthur was just around the corner in the Dai Ichi Building, the PX was just up the street in what is now the Wako Department Store, and the black market was in between—along with GI dance halls and the famous Yurakucho ladies of the night. Gone now, all except for this odd nook.

Something of the past lingers in Hibiya Park as well. Opened in 1903, it was a somewhat uneasy combination of Western and Japanese garden design—bandstand and malls versus gourd-shaped lake and stepping-stones. The Japanese section, in the southwest corner, remains almost unchanged. The wisteria trellis is still there, as is the crane fountain. Despite the highrise backdrop, there remains an air of Meiji grace. Tokugawa sternness also remains. Near the Hibiya crossing is a section of the original wall which ran along the moat. This is all that is left of Hibiya Gate.

There is little left of the original Ginza, however. Originally it was merely a mercantile district where the silver guild (ginza) was located. Then, after one of the city's periodic fires (that of 1872), it was lined with brick buildings in the latest style, a kind of Tokyo Strand. Now the brick buildings are gone, along with the willows which once lined the way, and Ginza is that Fifth Avenue–like street of stores and restaurants and coffee shops which to the tourist is Tokyo.

This and the Kabuki-za, just a few blocks away. Opened in 1889 and rebuilt in 1925, and again in 1949, it—along with the Meiji Shrine, the Asakusa Kannon Temple, and a few other places—seems very "Japanese" in modern Tokyo.

Here, too, in the Ginza district, one can still catch a glimpse of a rickshaw or two. Small in number, they are reserved for the use of the geisha who still entertain in the few such establishments left in Tsukiji.

Otherwise all is modern, that peculiarly future-oriented look which is contemporary Tokyo. It is right that this look begins in Ginza: here traditionally the old shitamachi, East End, stopped and the new yamanote, West End, began.

Below The crane fountain in Hibiya Park; the mall fountain, with the Imperial Hotel in the rear; Hibiya Park and a section of the Hibiya City complex; the Konpira Shrine in Toranomon, surrounded on all sides.

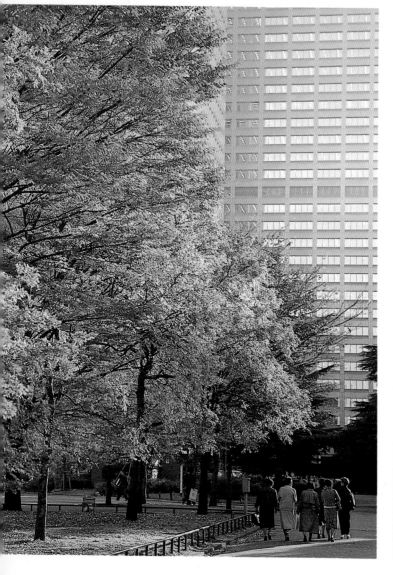

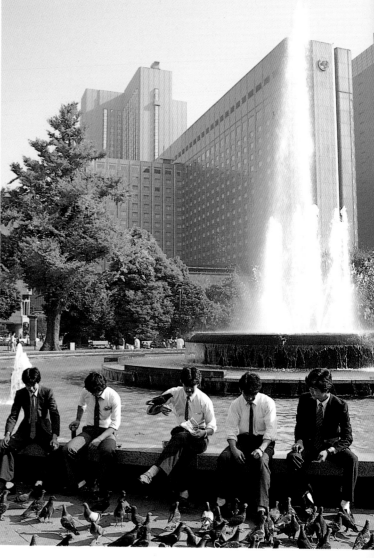

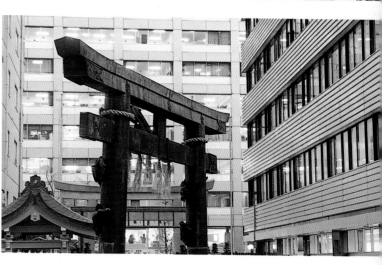

Left The Mullion Complex, a raised expressway cutting across its façade. *Right* The same from above, with a passing bullet train in the foreground; people resting at Yurakucho Theater; a Ginza subway entrance near the Yon-chome crossing.

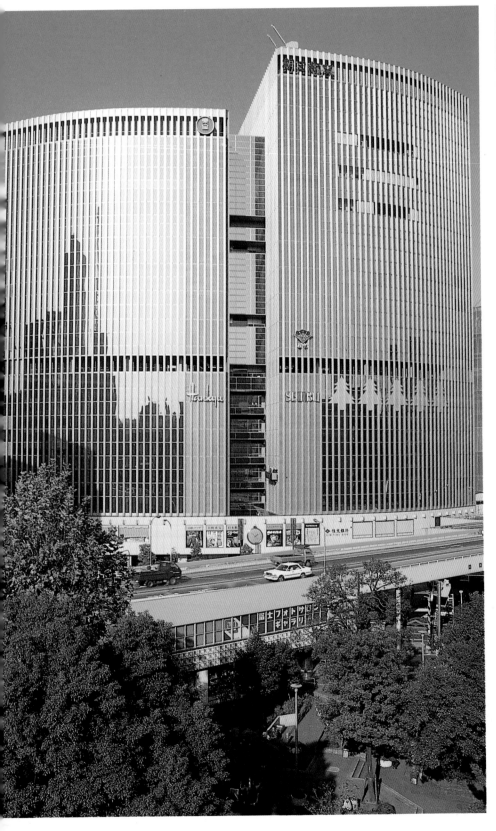

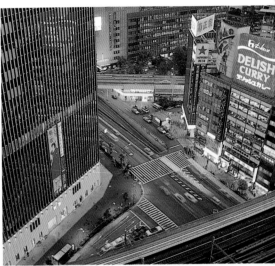

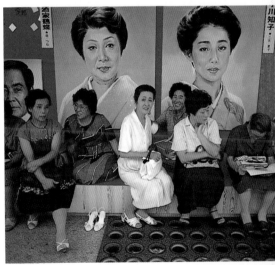

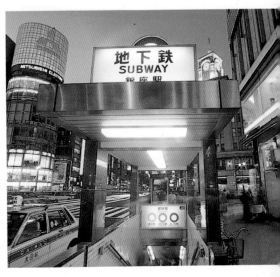

Below Looking north on the Ginza toward Kyo-bashi and Nihonbashi; Ginza coffee shop; waiting in front of Wako Department Store in the Hattori Building, a place for people to meet.

Opposite The Ginza Yon-chome crossing with the Hattori/Wako Building on the right.

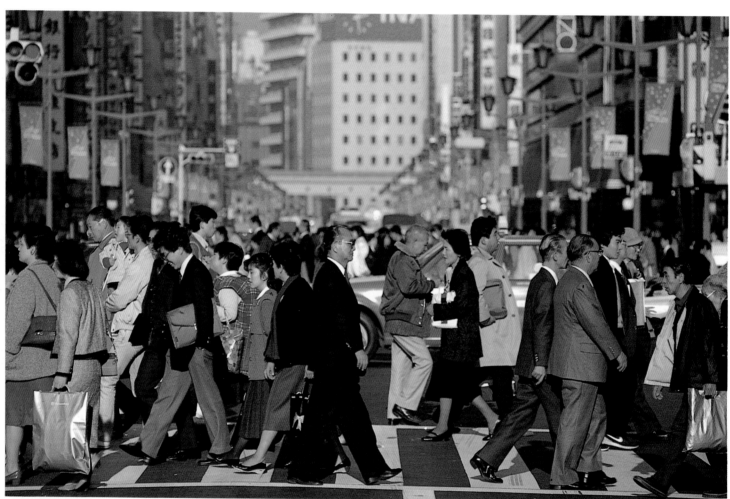

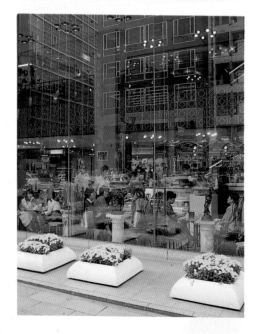

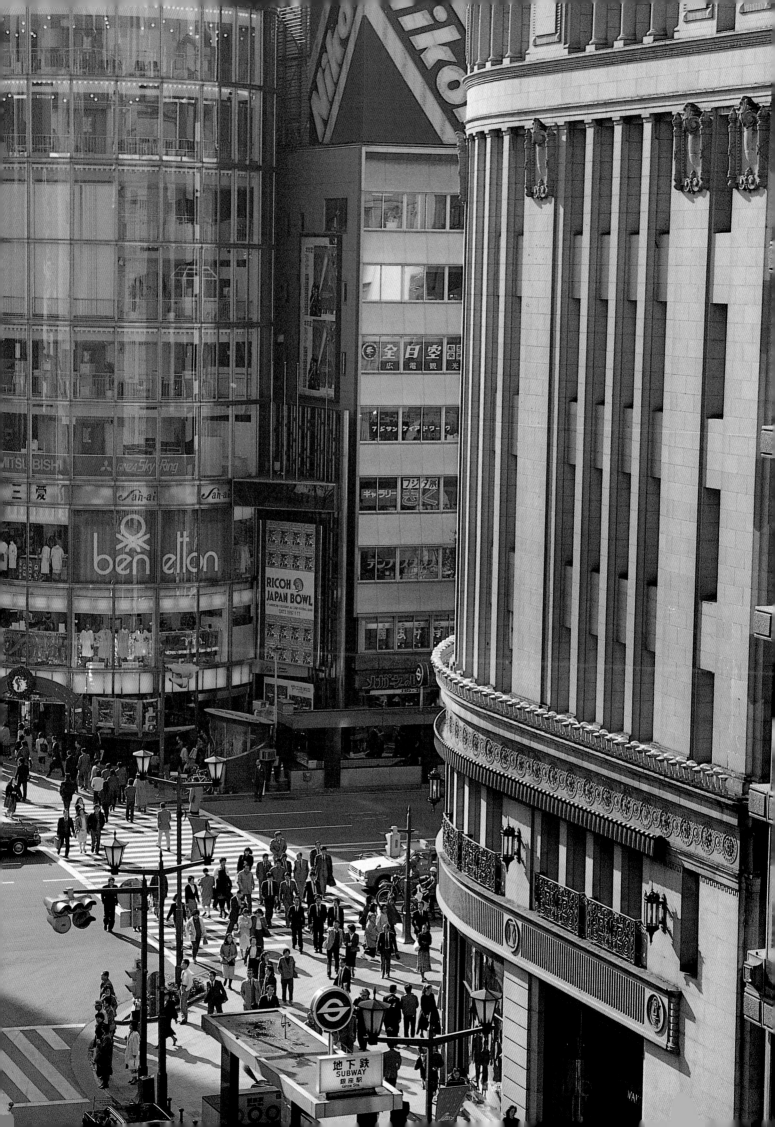

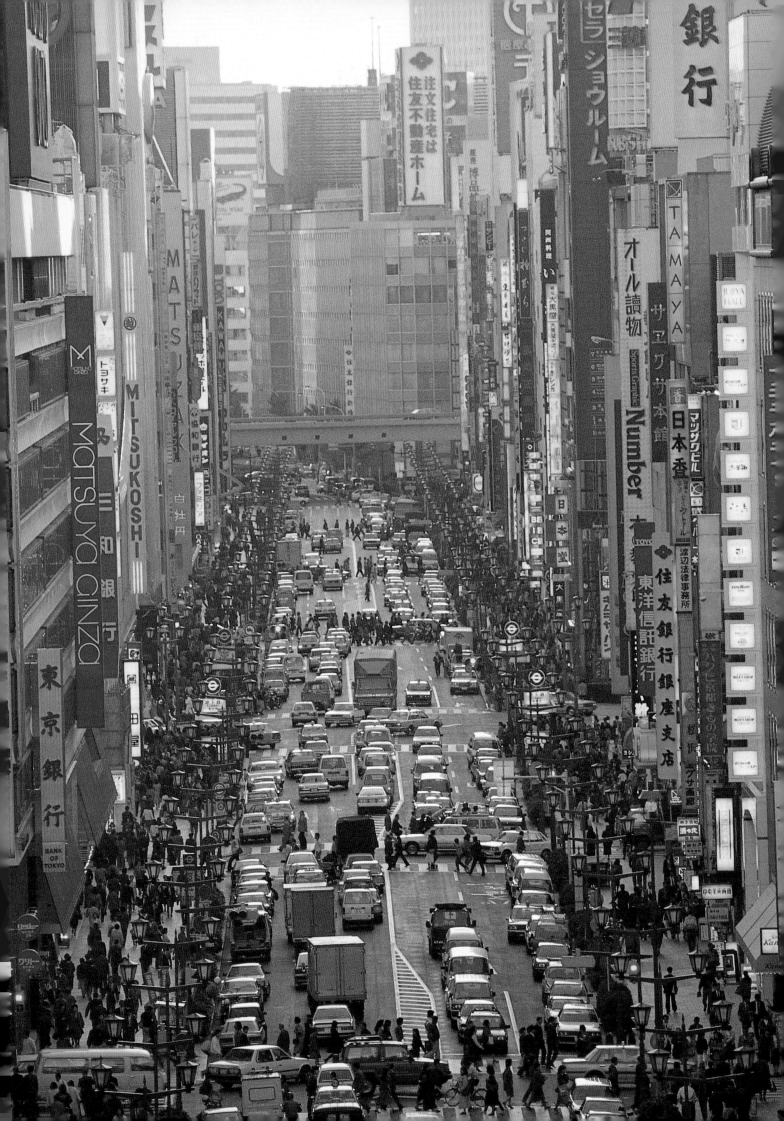

Opposite Looking south on the Ginza toward Shinbashi.

Below The Kabuki-za theater at night; traditional delivery—by bike; the back streets of Ginza—one man is on his early morning way to work, the other is cleaning up from the night before; there is actually a Ginza Yacht Harbor Club along one of the small canals near the district.

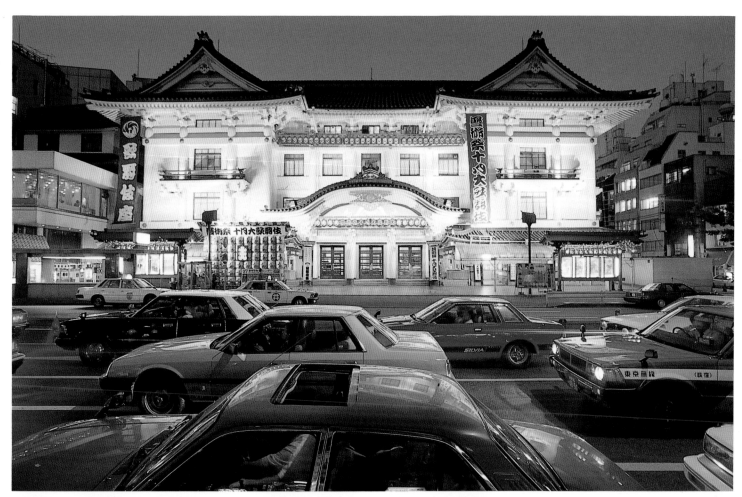

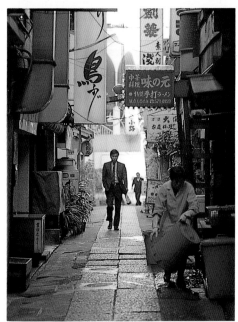

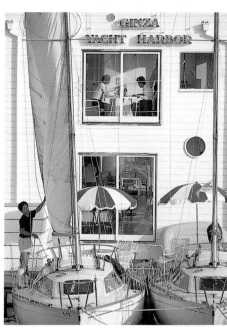

From Roppongi and Akasaka to Aoyama and Shibuya

For many visitors to Japan, "modern" as opposed to "traditional" Tokyo begins in the extensive night life of Roppongi. Here is where smart little restaurants blossom and discos bloom. And here is where many of the foreigners, visitors and residents alike, amuse themselves. It is they who lend Roppongi its international flavor.

And fittingly so. After World War II the Occupation forces moved into barracks recently vacated by the Japanese Imperial Army—for Roppongi had long been a barracks town—and the place was once more a garrison city, but this time with blue-eyed soldiers. It was thus, way back in 1945, that Roppongi became "international," and that young Japanese began visiting it as though it were a foreign city.

A mod bar-cum-snack.

It does look rather like Las Vegas, with its neon façades, its blinding strobe-light displays, its endless banks of blinking bulbs. And it remains one of *the* places where young Japan goes. As author Paul Waley has noticed: "One of the most striking tendencies of the Japanese . . . is to converge. They converge on Roppongi."

For how much longer one does not know. Things change—but more so in Tokyo. The informed young are, it is said, traveling to "exotic" Asakusa, finding traditional Japan much more like a foreign country nowadays. And the recent attempts at gentrification in old Tokyo would seem to support this. Certainly Roppongi is changing. The *jeunesse dorée* now go to Aoyama—from a Japanese West Village, Roppongi is becoming a Japanese Times Square.

Actually, one can still find a kind of tradition in Akasaka, just next to glitzy Roppongi. Though it has its big hotels, its nightclubs and eateries, though it also cultivates a "now" image, just off the main streets there are quiet residential streets with wooden, tile-roofed houses, even a few geisha houses. Just over the hill from the Diet, it was (and still is) favored by politicians and businessmen when they wanted an unbuttoned drink or two and did not want to go to politer Shinbashi, where they had to watch their manners.

Aoyama, too, has its history. Though Aoyama-dori, that broad avenue of boutiques and fashion shops (from Brooks Brothers to Issey Miyake) which extends from Akasaka to Shibuya, gleams with chic, nearby Aoyama Cemetery, one of the city's most extensive, is one of the best places to view the traditional cherry blossoms. Aoyama is also home to one of the finest of private museums, the Nezu Museum of Fine Arts, standing in the best of the *yamanote* Japanese-style gardens.

The new is again encountered in Shibuya, the end of Aoyama-dori, the end of the Ginza Subway Line, and the end of midtown Tokyo. Here is a congregation of department stores, shops, restaurants, theaters, and people, people, people. Nowhere in Tokyo, even Shinjuku on a Saturday night, feels quite as crowded as Shibuya does.

It is all modern, all mercantile, though not as trendy as the Roppongi–Harajuku axis. The young Japanese who gather here do not seem to find Shibuya especially "international." One does not come here for a peek at the latest fashions or the newest imports.

The architectural mélange of Shibuya is just as pronounced, however, as it is everywhere else in the *yamanote*, and offers yet further affirmation of what Isabella Bird long ago noted: "It is singular that the Japanese, who rarely commit a solecism in their own . . . architecture, seem to be perfectly destitute of perception when they borrow ours."

Department-store complexes have taken up large sections of the area and given themselves over to the kind of architectural advertisement that department stores in Japan indulge in. One such is a boutique aggregation which calls itself Fashion Community 109—all postmodern glass and metal, looking something like an oil refinery.

And yet, not all is mindless progress. The very human can still be found: In Shibuya, at one corner of Fashion Community 109, is a little old Japanese shack and solitary tree. It is owned by a gentleman who refused to sell, though reportedly offered huge sums of money. So there he still is and behind him, mindless, baffled, looms the fashion monolith, the owners of which were forced to alter their ground plans because of this little shack, this single tree.

However, such dereliction is rare. Someone, looking out over glittering Shibuya, said: "It looks just like a scene from *Blade Runner*!" And so it does. The futuristic sets of that SF-thriller were, after all, modeled after the reality of modern Tokyo. The difference, of course, is that this Tokyo will not last any longer than any of the others, and that it is vastly more benign than the L.A. of the film.

Below left The Roppongi crossing with the Almond Coffee Shop, a place where the young meet; the Ark Hills complex near Roppongi; interior of the Roppongi bar Nomad, a fitting name because it was built merely to help defray property taxes while the owners negotiate for more land for a bigger building. *Right* Roppongi scenes, including a restaurant near Tokyo Tower shaped like St. Basil's.

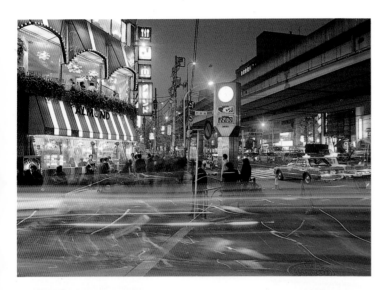

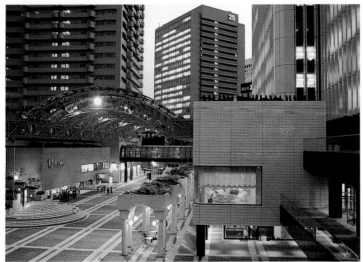

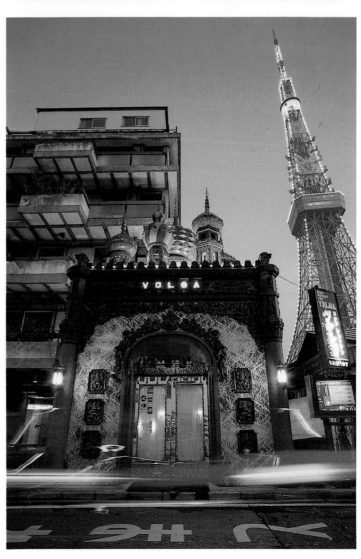

Below Akasaka-mitsuke, the main avenue of which leads to Aoyama and Shibuya; in the foreground, the Benkei Bridge and a section of the old moat. *Right* The moat with the New Otani and Akasaka Prince hotels; Akasaka bar with signs indicating both that it is a *taishu kappo*, a popular pub, and that it accepts plastic; an Akasaka restaurant worker.

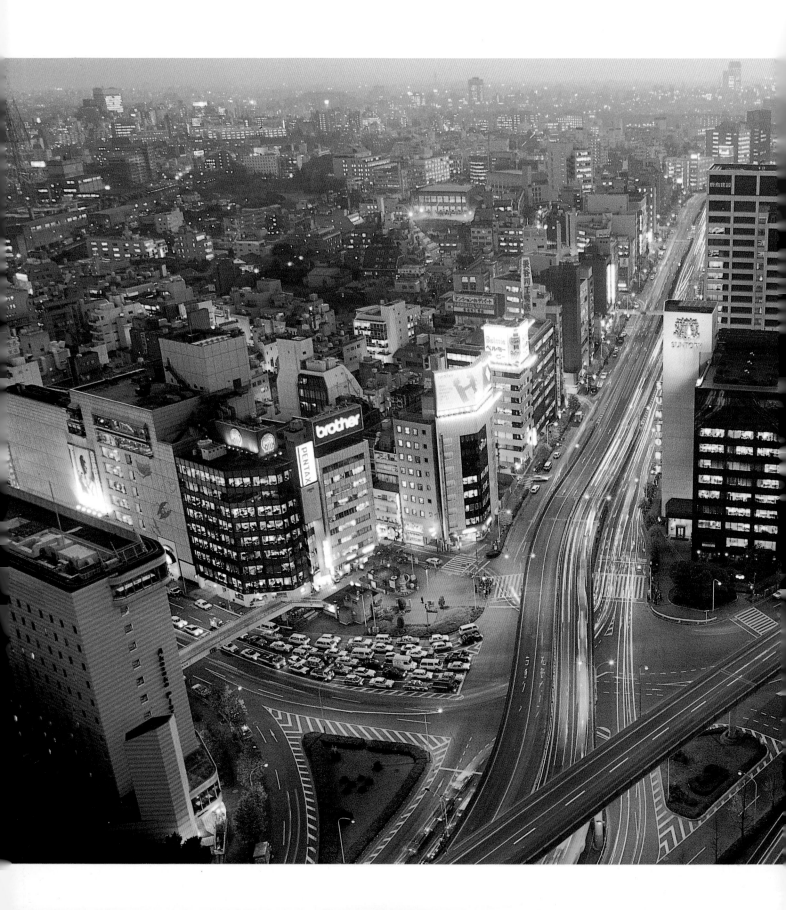

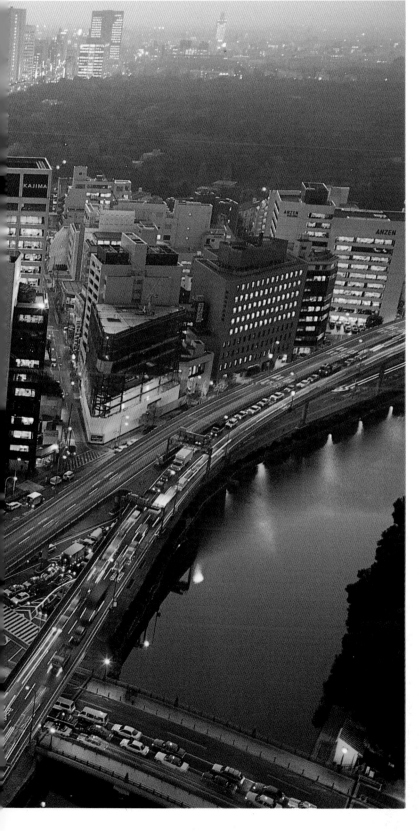

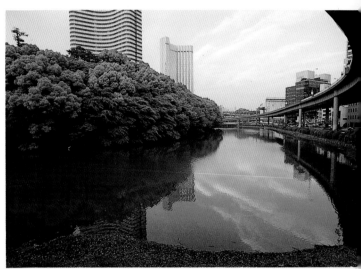

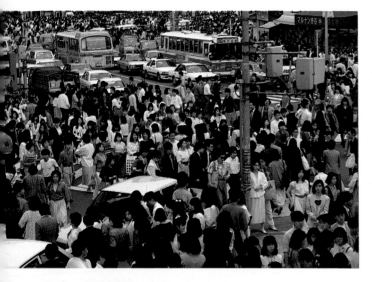

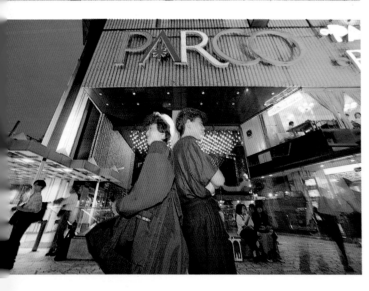

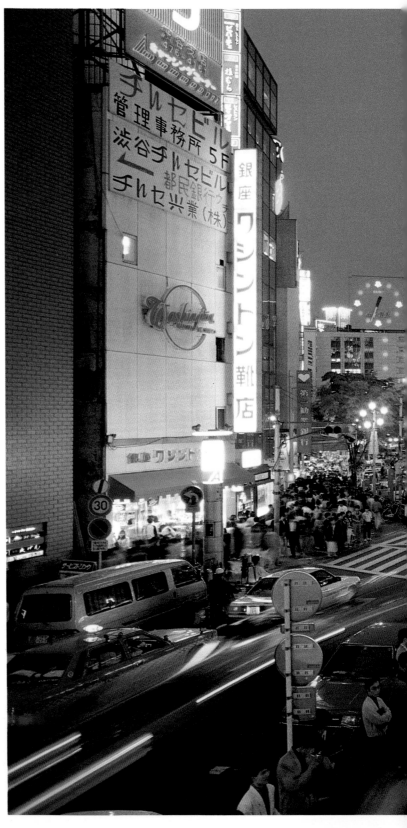

Left Scenes from Shibuya: the crowds, the mercantile endeavor, and whole sections dominated by such department-store giants as Seibu, Tokyu, Parco. *Below* Department-store culture: goings-on in front of the large boutique conglomeration Fashion Community 109—a rock concert with lights, color, and mannequins aloft.

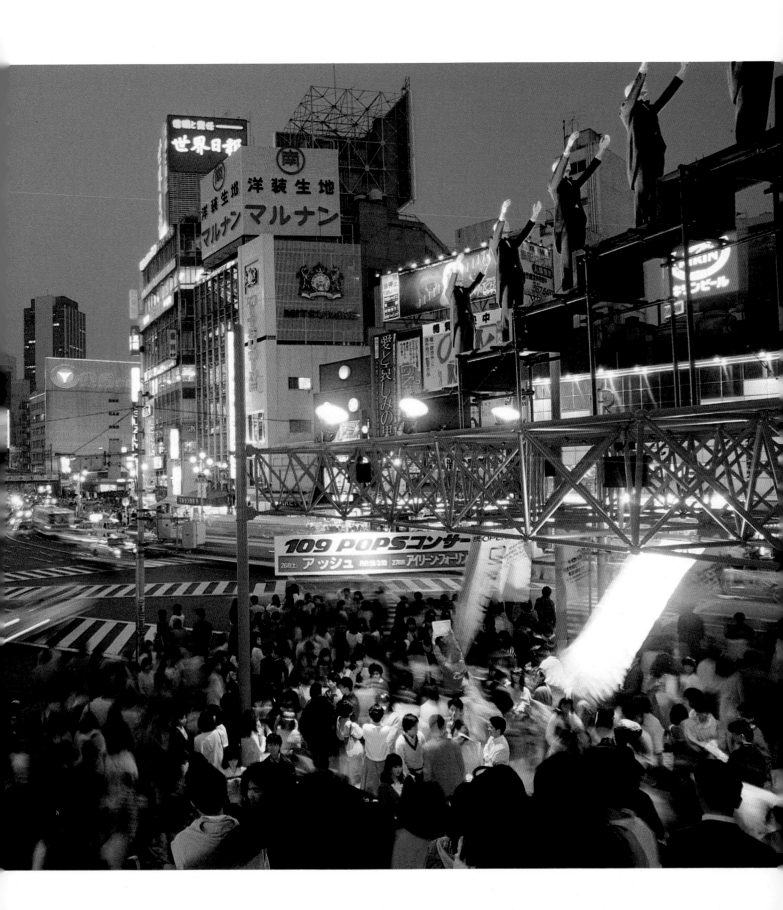

Scenes from Aoyama: The Gallery in the Spiral Building—it features "modern art"; a modern and expensive boutique for the young; a typical Aoyama-dori boutique; one of the many continental-style restaurants, this one serving Pernod and imported beer; a pair of Aoyama girls, members of the affluent young.

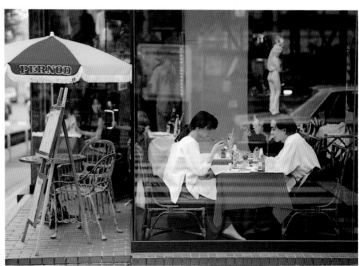
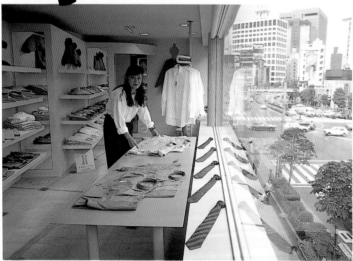

Omotesando, Harajuku, the Meiji Shrine, Meiji Park, and the Shinjuku Gardens

Omotesando is the big, wide, zelkova-tree-lined avenue which the young call the Shanzerize—Tokyo's own Champs-Élysées. Omotesando and Harajuku, toward which the former leads, are—now that fashion is big business in Tokyo—couturier towns: all boutiques and brand names. This is where the big guns in fashion have their GHQs and where shops have such names as Ambiente Aoyama and Comme ça du Mode.

Since it is mainly the young who have made fashion a big business, it is fitting that Tokyo's Champs-Élysées should lead to the "young town" itself—Harajuku.

One sees them out in force of a Sunday, the young, when they take over in all their finery, occupying the entire roadway in front of the big National Gymnasium as a showplace for their dancing skills.

Here they are in a dozen guises and costumes, from Punk to Fifties Rock. The Rockers sport hair slicked back and black leather, rocking and rolling, though not one of their number was born when Elvis was king. Here, too, the sixties hold sway: teen-age groups with saddle shoes, pastel blouses, and the Twist. Also, a clump of teens in those odd, brightly colored designer sacks, "descendants" of the original Takenokozoku (which might be rendered as The Bamboo Kids), who started this whole fad of dancing in the street of a Sunday afternoon.

It is all very benign. The black leather does not connote violence. It means well-mannered adolescent aspiration. Though the city fathers do not smile on such manifestation—it all smells too strongly of the spontaneous, something always to be regarded with suspicion—they do halt traffic on the street so that youth may have its fling.

That such noisy (boom-boxes in constant use) and lively goings-on should occur directly in front of the main entrance to one of Tokyo's most quiet, secluded, and serene spots, the Meiji Shrine, is typical of the sometimes schizoid extremes of this capital.

Leaving the packed and cavorting avenue and entering the shrine precincts, one is returned to the natural world, to a forest right in the heart of Tokyo. It is said to have over a hundred thousand trees, this forest. It looks like it—dense, green, beautiful. Most of the trees are green year round, and

An all-boutique emporium.

so no matter the season the glistening leaves, the quiet, the dark shadows make the forest of Meiji Shrine a magical experience, particularly in contrast to what is going on just outside the entrance. Here in the midst of this scintillating modern city is a part of the primordial world.

Actually, the Meiji Shrine is not that old. The land had belonged to one of the daimyo families, and when it reverted to imperial hands it was decided that a shrine to the Meiji emperor, then just recently deceased, would be appropriate. Work was begun in 1915, three years after the ruler's death.

The buildings themselves, reconstructed after World War II, date from 1958, but they seem as venerable as the forest in which they are found. Passing through the mighty *torii* gateways and walking along the graveled avenues leading to the heart of the forest, one sees the shrine ahead—at a turn in this pebble boulevard (one of the most dramatic turns in all of twisted Tokyo), there it is: the copper roofs, the white gravel courtyards, the plain wooden pillars, shining in the sun or softly glowing in the rain—very beautiful, very serene.

Except for once a year. This is the four-day period beginning at midnight, the first hour of the New Year, when several thousand people cram into the courtyard. In the following four days over four million will pay their respects. This pilgrimage, thousands at a time, fills the forest with its roar.

Beyond Meiji Shrine are two other wooded areas. One of these is Jingu Gaien, the outer garden of the shrine, now given over almost entirely to sports facilities and a collection of Meiji hagiography—the Meiji Museum.

Somewhat farther away and to the northeast is Shinjuku Gyoen—Shinjuku Gardens—an immense (145-acre/58-hectare) expanse of green. The northern part is a Western-style park with broad lawns and flower beds, including a garden in the classical style, and the southern is all Japanese with paths and ponds and islands. There is also a large greenhouse for tropical exotica.

From these gardens one can see, looming in the background, the towers of Shinjuku. You look up from the banks of ancient pine and see the Sumitomo Building, a contradiction which is yet another indication of high contrast in modern Tokyo.

Scenes from Omotesando and Harajuku: *Below*
The Champs-Élysées of Tokyo, where the youth
of Japan parades and purchases. *Opposite* The
people of the "young town" of Harajuku on a
Sunday afternoon in their varying degrees of
finery.

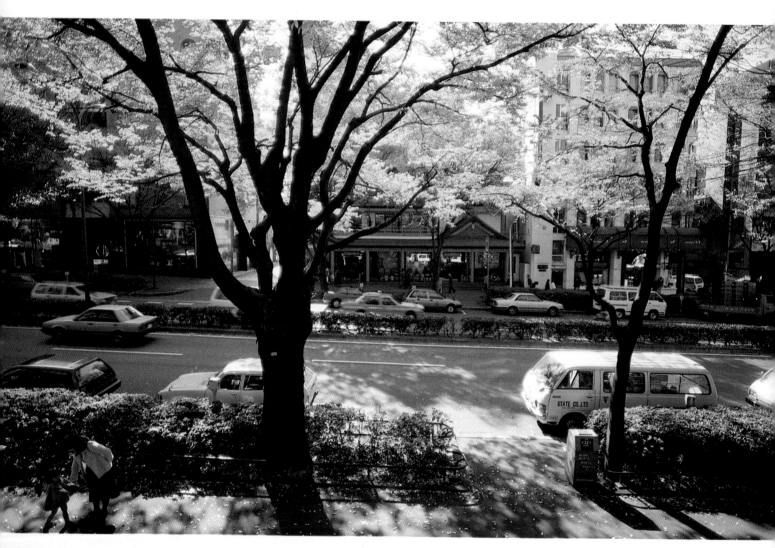

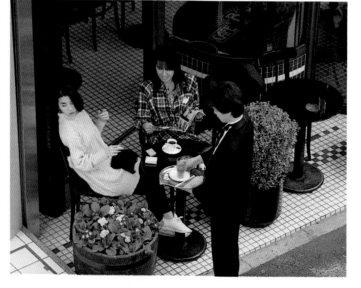

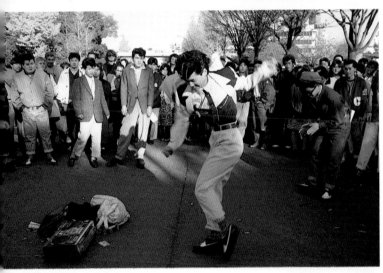

Below Meiji Shrine, also in Harajuku, just a short walk from the crowded, cavorting avenue—the main *torii* gateway fronting the wooded shrine precincts; a family paying a formal visit; two girls in kimono head up the gravel path toward the shrine to celebrate Coming-of-Age Day.

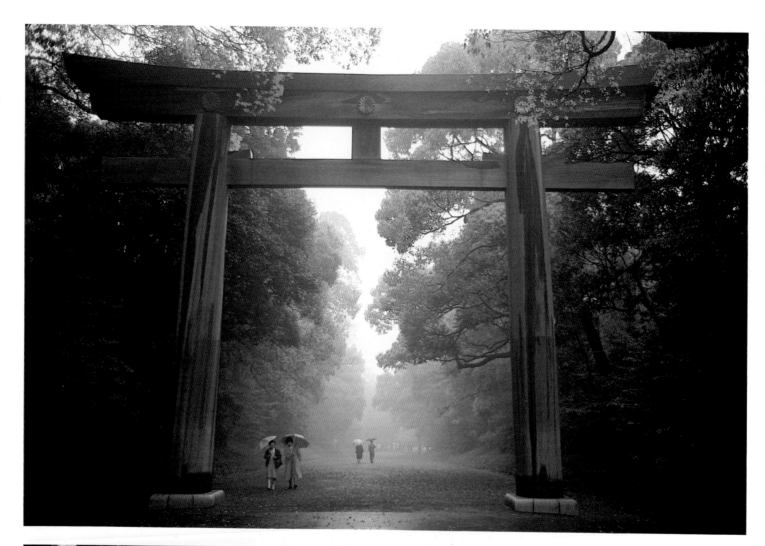

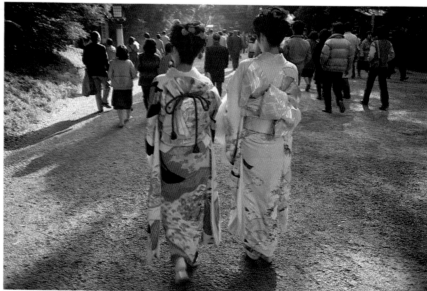

Below left New Year's is also a time for kimono.
Below right The avenue of gingko trees in the outer gardens.

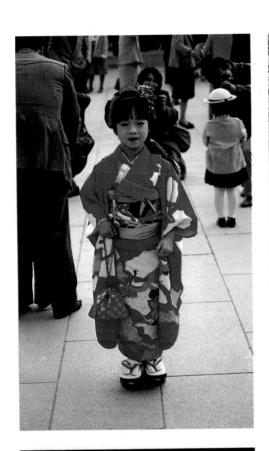

58

The Shinjuku Gardens: children and cherry blossoms in spring; an amateur painter in the fall; over the greenery rise the skyscrapers of Shinjuku, the skyline of western Tokyo.

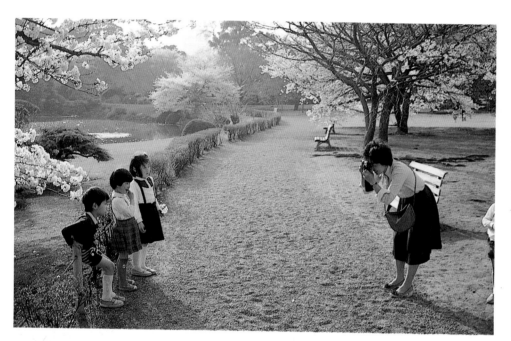

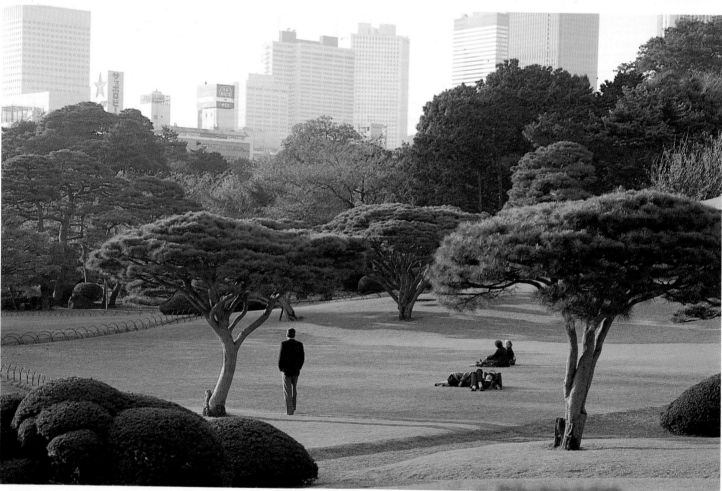

7
Shinjuku

"Shinjuku never sleeps" is the slogan—it is meant as a recommendation. For, though the capital as a whole winds down early as capitals go, since public transportation grinds to a halt just past midnight, Shinjuku has taxis on the roll and people on the streets all night long. Come here to play, and play all night if you want. Indeed, Shinjuku never sleeps—it is a night city in the great tradition of Montmartre in the early years of the century and Times Square in the middle decades.

Symbols of Modern Japan.

In the daytime it is an ordinary mercantile district, though an extraordinarily busy one—1.2 million commuters a day converge on Shinjuku Station via eight train and subway lines and thirty bus routes. The town bustles day *and* night, though these aspects differ. The district is, as Mark Girouard has written, "a basic townscape of dirty concrete and material resembling cardboard, already turning tatty after a life of ten or twenty years. It is only at night that entertainment districts lose their daytime junkiness and become a wonderland of neon lighting, for the old Japanese genius for fireworks has transposed naturally into modern electronics."

Shinjuku blossoms at dusk, becoming the extraordinary nocturnal experience that has made it the main entertainment section of the capital. A local brochure proclaims Shinjuku to be "the new heart of the city." And so it is, just as Asakusa, with its pleasure quarters, was the old.

Shinjuku does not, however, have much in the way of a history, nor does it need any. Originally it was an authorized stop on one of the main roads to Edo. New lodgings were built there, and that is just what Shinjuku means, "new lodgings." It was not until the era of the railroad that it began to emerge as a nightspot, and not until the sixties that it became the new pleasure quarters—everything that the "floating worlds" of Asakusa and the Yoshiwara once were, and much, much more.

At the same time, Shinjuku was coming into its own as a business center, boasting Tokyo's only real skyscrapers. The first was completed in 1971 and they have been going up ever since. In addition, the Tokyo metropolitan government now has its very own skyscraper complex. Though there are higher buildings—the sixty-story Sunshine City in Ikebukuro, which boasts a museum, an aquarium, and a planetarium besides—the fifty-some-story clustering towers have come to typify Shinjuku, "the city of the future" as it likes to call itself.

This, however, is only in the area west of the station. Shinjuku, like Tokyo itself, has its east and west ends and displays like contrast. West Shinjuku is all skyscrapers and wide, windy avenues, civic endeavor at its most apparent; East Shinjuku (on the other side of the station) is something else.

It is a warren of lanes and streets and alleys extending over a very large area, all of it brilliant with electric displays which dazzle and blind. Most are concerned with advertising, and here one feels as G. K. Chesterton did on Broadway: "What a glorious garden of wonders this would be to anyone who was lucky enough to be unable to read." These streets lead to the very heart of the pleasure maze: Kabuki-cho.

This area has no connection with the Kabuki theater, though it was once promised one. After the war it was thought that instead of restoring the burned-out Kabuki-za (which is what eventually occurred), the entire theater would be moved from the Ginza area to Shinjuku. Protests from the residents, it is said, resulted in the abandoning of such plans.

One wonders if the residents are pleased with what they got instead. For pleasant as the place is for pleasure-seekers, one would not, I think, want to live in Kabuki-cho. It is packed, noisy, rowdy, and never goes to sleep. It is also the home of upsetting architectural wonders. A medieval Japanese castle contains a branch of a popular yakitori shop; a plastic-ivy-covered Tudor castle houses a coffee shop, a disco, and a "mammoth" bar; the Fontana di Trevi (in plastic) makes doubly memorable a *pachinko* parlor facade.

It is also home to the sensual comforts. Not only are there hundreds (some say thousands) of bars and all sorts of baths (Roman? Finnish? Turkish?), there are all kinds of restaurants and all kinds of theaters (from the stadium-sized Koma Stadium to the flea-pit porno)—and there are, in addition, multifold outlets for the carnal appetite. Like Yoshiwara before it, Shinjuku is a capital of the flesh. It is a great nightspot, a noisy, boisterous cornucopia of entertainment, and one of Tokyo's best entertainments. One is really inclined to think of Shinjuku as Henry James thought of England's capital when he said that it was "the particular spot in the world which communicates the greatest sense of life."

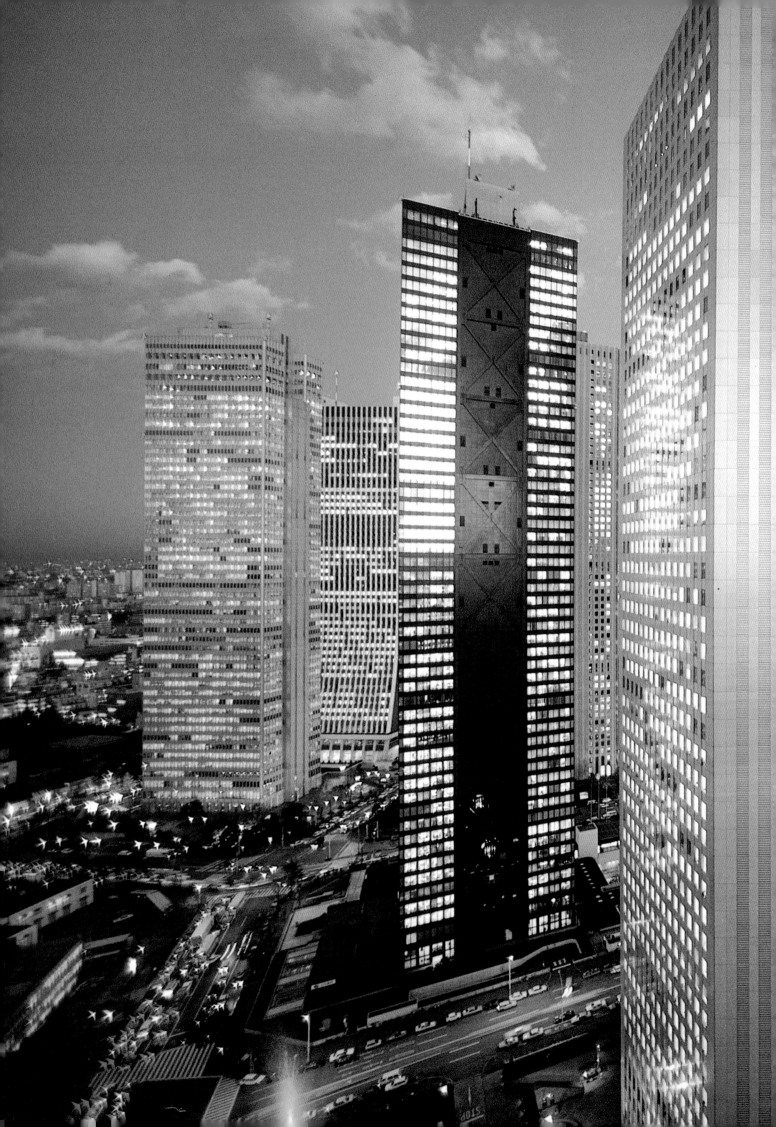

Opposite The Shinjuku skyscraper complex west of the station. *Top* A view of the futuristic new Tokyo Metropolitan Government office Building, the nation's tallest structure. *Bottom* The entrance to the Tokyo Metropolitan Government Office Building leads thousands of visitors to the Observation Tower on the 45th floor, only a one-minute elevator ride from ground level.

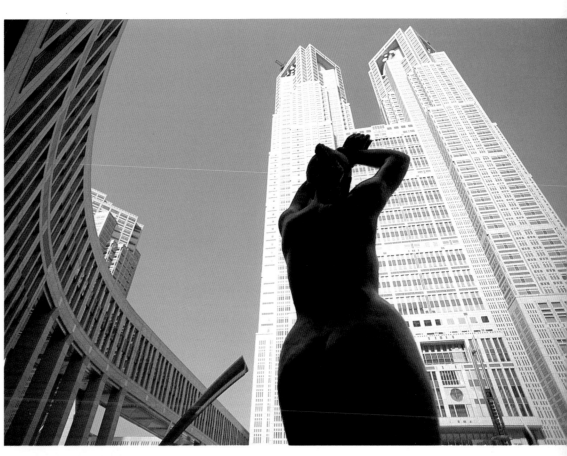

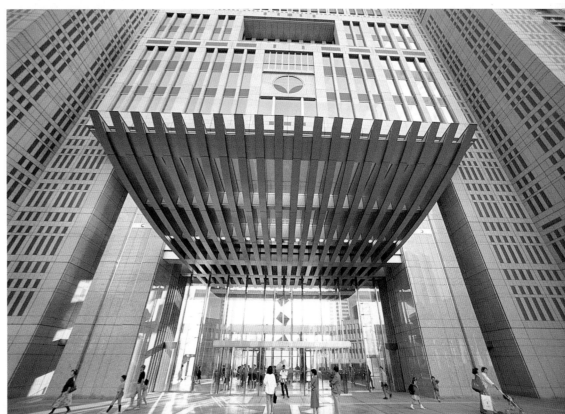

Overleaf **The Shinjuku skyscraper complex west
of the station.**

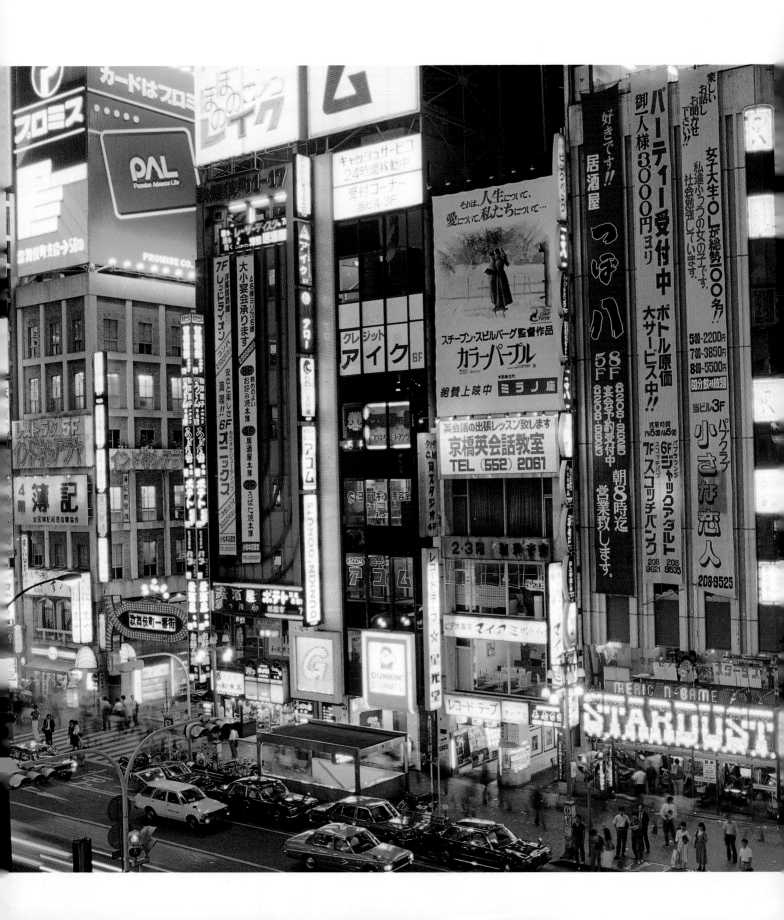

Opposite and below Shinjuku east of the station; the arcades leading to Kabuki-cho; salt-grilled prawns being sold; on the street in Kabuki-cho; the station area with the big screen of Studio Alta; two typical Shinjuku conveniences—the capsule bed and the *pachinko* parlor.

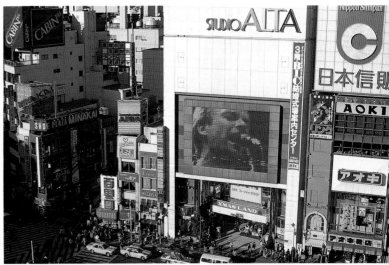

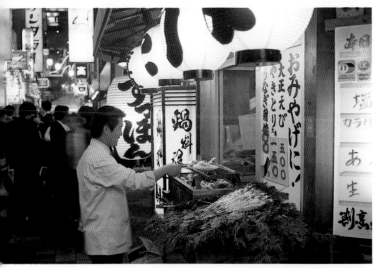

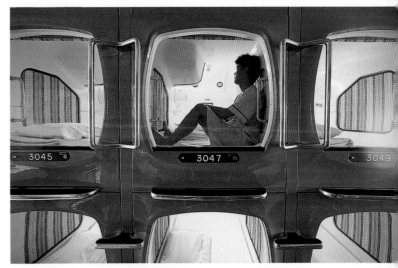

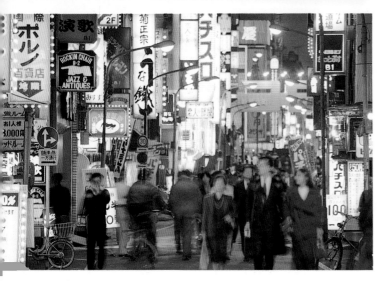

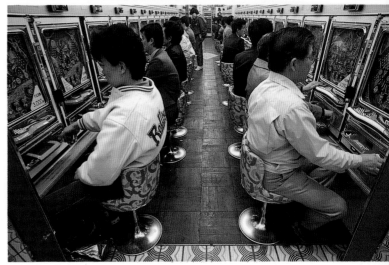

East and West, old and new—Tokyo.

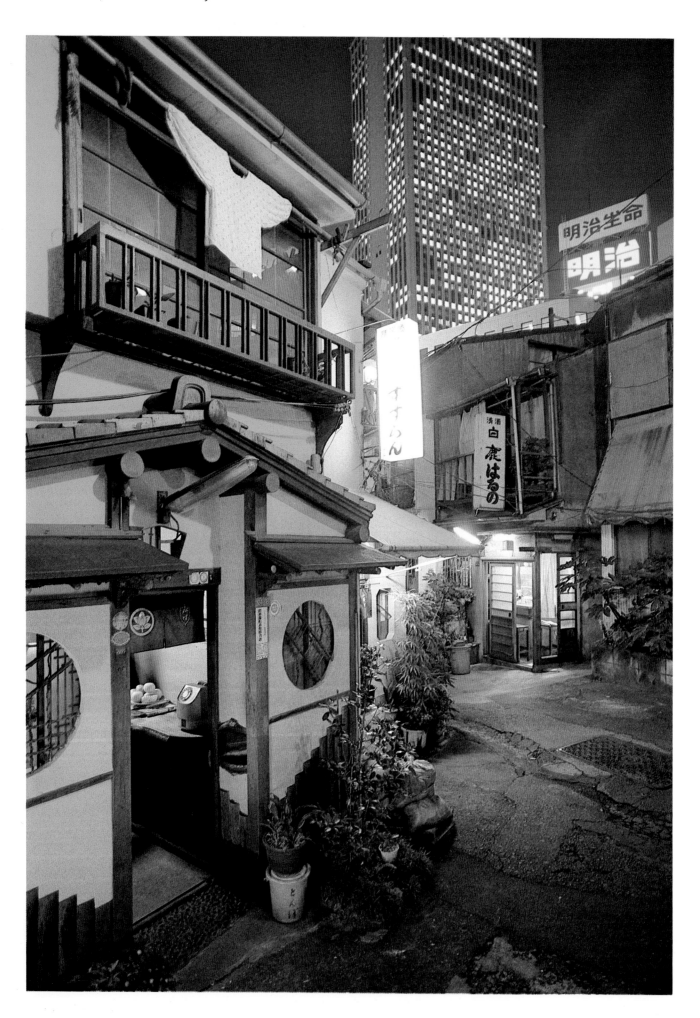

History: From Edo to Tokyo

Edo, the original name of Tokyo, first appears in written records at the end of the twelfth century. This early account states that one of the shogun's officials was made a political agent for the province of Musashi and settled in Edo, at the end of the Kanto Plain.

His residence was located near the mouth of the estuary where Tokyo now lies. It was part of a fishing village, apparently on a height—perhaps one of those ridges of small hills which are still a part of the city.

Whether this early official named himself for the place or whether the place was named for him is a matter for conjecture. Edo means "river mouth" and was the family name. Later, when this land was divided among the descendants, the sons and grandsons apparently took their names from the land they acquired, names which are now well-known Tokyo place names—Shibuya, for example.

The reasons for this early settling in Musashi were various. The Kanto was the largest of Japan's alluvial plains and the one best adapted for agriculture. Also, it was farthest from any potential invader from the mainland. And finally, it was good for the raising and exercising of horses, something in which the new warrior class was much interested.

It was near this original Edo household, and apparently close to the site of the present Imperial Palace, that Edo's first castle was built. This was the work of Ota Dokan, a fifteenth-century vassal of the Ashikaga shoguns. It was completed in 1457, and this date is still officially commemorated as the year of Tokyo's birth. (Ota is still in a way associated with the Tokyo government. A statue of him stands near the Tokyo Metropolitan Government Building in the district of Marunouchi.)

A well-fortified castle had become necessary as Japan was again experiencing one of its seasons of civil war. The site was highly strategic: it was on a height, faced the bay, and had the river. It also served, not incidentally, to enlarge the lord's landholdings.

Toward the end of the civil wars one of the major territorial exchanges of Japanese history was arranged. The de facto ruler of the country, Toyotomi Hideyoshi, offered the eight eastern provinces to his most powerful ally, Tokugawa Ieyasu, in exchange for three provinces closer to the capital, Kyoto. The latter agreed and his acumen in accepting such distant territories was soon evident. When he emerged as shogun, ruler of all Japan, his base of power was already at hand.

In 1590 Ieyasu made his formal entry into the small town that was to be the military capital of the nation. A site near that of Ota's stronghold was to become one of the greatest castles of the time, and the resulting city, Edo, one of the greatest cities of the world. Almost at once he began construction. Cyclopean walls were built, tower after tower was constructed, moats were dug. A mighty castle emerged.

Even now its original plan is visible, though most of the moats have been filled in. Some of them have even become sunken expressways, winding their way through the center of the city, following the lineaments of the original moats.

The castle was a city in itself, a collection of residences rather than a single building, all surrounded by walls and protected by watchtowers and massive gates. And it was truly enormous, as Richard Cocks, one of the few Westerners

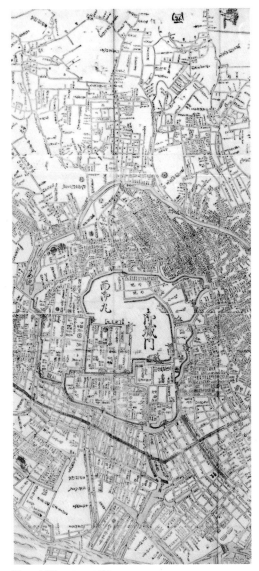

Map of Edo, circa 1680.

to see it, wrote in 1616: "We went rowndabout the Kyngs castell or fortress, which I do hould to be much more in compas than the city of Coventry."

Yet, by the time the last touches were added to this great castle-town in 1640, its very success had rendered it obsolete. There were no more internal enemies, and invaders from outside would not appear for another 250 years. The construction of this mighty castle had taxed everyone poor, especially former enemies, and the shogunate's system of repression had been so successful that there was no one left to challenge the castle of the Tokugawa clan.

The succeeding generations of Tokugawa shoguns made certain that repression was continued, that obedience was enforced, and that the very distance of Edo from anywhere else worked to shogunal advantage.

All of the territorial daimyo nobles, originally some three hundred in number, were required to maintain expensive residences in Edo as well as those in their home territories. In addition they were made to travel back and forth at regular intervals with a retinue befitting their rank, a costly enterprise that served to further drain their coffers and made an attack against the shogunate an economic impossibility. Finally, they had to leave behind in Edo members of their family who were, no matter what polite fiction was used, simply hostages.

Though these constant comings and goings of high-ranking lords and their retinues of samurai retainers, servants, and tradesmen impoverished the daimyo households, Edo flourished as a center of trade to a degree then unknown elsewhere in the world. The city consequently began to grow at an unprecedented rate. By 1630 its population exceeded half a million, excluding the shogun's retainers and the families of the daimyo. Some fifty years later the population had doubled.

The city was also growing physically. Originally the castle was near the sea,

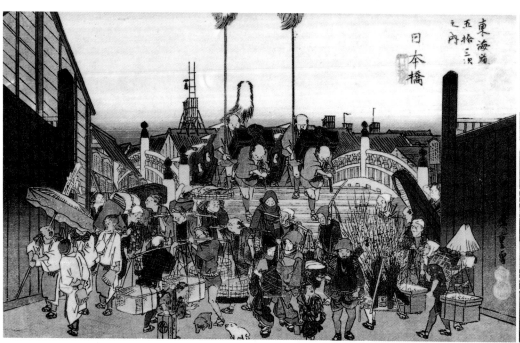

The bridge Nihonbashi, circa 1830.

Fireworks on the Sumida in Ryogoku.

but, as the city grew, more and more land was reclaimed from the bay, and the city limits were pushed farther and farther in all directions.

The military-camp-like atmosphere of early Edo reflected the fears of the ruling bureaucracy. The classes were to be separated. Everyone was to have his own place and there was no leaving it. Samurai were to live apart from the merchants; craftsmen would be assigned to areas by trade. This idea was extended to foreign affairs as well. From 1639 a program of national seclusion was adopted. Except for the port of Nagasaki the country was officially closed to all outsiders, and those who slipped in were executed. Likewise, any Japanese venturing abroad could not return, under pain of death.

While some of the dictates of the Tokugawa police state continued, not all of them were successful. The confining of the various trades, for example, was soon abandoned. The city was growing too fast and was, in addition, subject to the usual number of conflagrations. There was a particularly disastrous blaze in 1657, and between 1603 and 1868 no fewer than ninety-seven major fires swept through sections of the city.

Yet despite these, and despite shogunal restrictions, Edo continued to grow. Once past Tokugawa perimeters, it spread in that nicely random fashion we associate with modern Tokyo. By the beginning of the eighteenth century, it was the largest city in the world. In 1780 its population was a stable 1.3 million, in an age when the population of London was only 850,000 (1801).

In Edo flourished the famous world of the *ukiyo*, the floating world of pleasure which the print artists liked to portray—the pleasure quarters, the Kabuki theaters, the bathhouses. No matter the various governmental restrictions (and there were so many that no single one could be considered efficacious), the culture of Edo thrived.

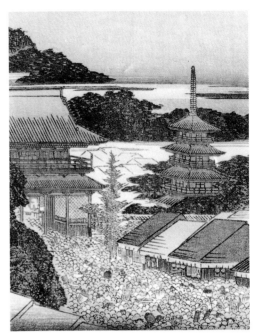

A thronged Asakusa Kannon Temple.

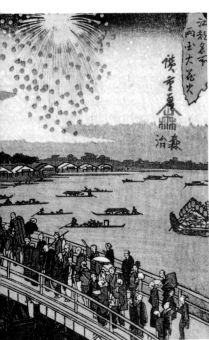

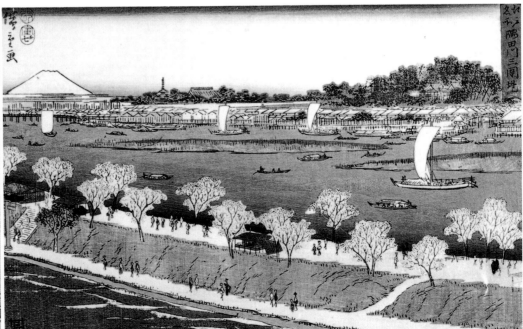

The Sumida River, with foot and water traffic.

Over the centuries, however, even the most repressive of governments loses force. This happened eventually to the Tokugawa shogunate. By the time the famous Black Ships of Admiral Perry were sighted off Tokyo Bay in 1853, the Edo government was unable to defend the country.

The result was the first of a number of treaties, and in 1867 the shogunate system came to an official end. With the restoration of the emperor the following year, Edo—renamed Tokyo (Eastern Capital)—became the capital of Japan. The imperial family moved into Edo castle in 1868, and most of the Tokugawa regulations (separation of samurai and merchant quarters, for example) were, at least nominally, rescinded.

So, too, was Japan's long period of seclusion. Tokyo and the rest of the country began modernizing. The new government decided that Japan was to "catch up" with the West. "Highways," streetcars, trains, telegraph lines, telephones, and electric lights began to appear—along with the bustle, the frock coat, and the waltz. Soon Tokyo was the mighty capital—part traditional, part modern—that it continues to be.

Disasters also continued. There was the Great Kanto Earthquake of 1923 and then the Allied firebombings of 1945, both of which destroyed much of what had been left of Edo. Still, the *edokko* spirit sustained itself. Reconstruction was begun at once, authoritarian city-planning outlines were ignored, and Tokyo rebuilt itself in its own natural way.

It is once more among the largest cities in the world and is again almost Edo-like in its merchandising, its unabashed consumerism, and its hedonistic and quite *ukiyo*-esque charm. And though its modernity is evident on every corner, Tokyo somehow manages to suggest something of the varied history that made it the great city that it is.

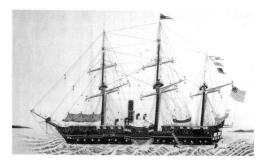
Contemporary depiction of Perry's ship.

Prewar Yurakucho, 1930s.

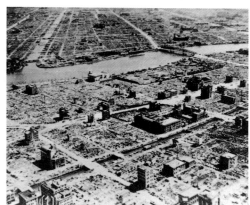
Firebombs and the resultant fires devastated most of Tokyo.

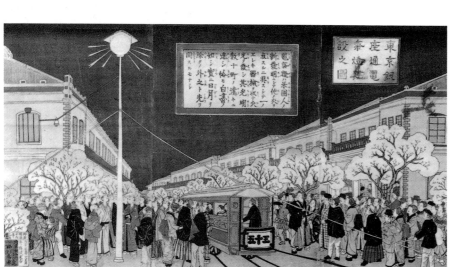
Modernization: Western clothing and Japan's first electric light, Ginza, 1833.

City Administration

The greater Tokyo metropolitan area encompasses not only Tokyo Prefecture but also the three adjoining prefectures of Saitama, Kanagawa, and Chiba—covering an area of roughly 2,300 square miles (1,600 square kilometers) and containing 28 million people, more than a fourth of the nation's population. Tokyo Prefecture itself, the city proper, is a self-governing unit consisting of 23 wards, 26 cities, 7 towns, and 8 villages, with some 12 million residents within some 830 square miles (2,150 square kilometers).

Tokyo Prefecture stretches about 55 miles (90 kilometers) east to west, and some 15 miles (25 kilometers) north to south. Technically, however, it extends much farther, since it also includes the Izu Islands and other island groupings hundreds of miles offshore.

Most people tend to think of Tokyo as the area of the 23 wards, and all the far-flung rest as the "suburbs." In the wards, an area of some 227 square miles (590 square kilometers), live 8.5 million, or 71 percent of the prefecture's population. These are distributed at a density of 36,000 per square mile (14,000 per square kilometer), a high ratio indeed.

Millions more work "within" the city, commuting daily from their homes in the surrounding areas. In the three central wards (Chiyoda, Chuo, and Minato), the daytime population is 6.8 times that of the nighttime population.

Governing this vast, sprawling, metamorphosing metropolis is a very complicated matter. The administrative system is divided into the legislative (the Tokyo Metropolitan Assembly) and the executive (the governor, administrative bureaus, and commissioners). All administrative functions are under the office of the governor, though some—the fire department, for example—are accorded a measure of independence. The members of the 127-seat Tokyo Metropolitan Assembly are elected by direct popular vote, and the members elect the president of the assembly. He represents and supervises its affairs.

Any metropolitan administration tends to become complicated, and for this reason the assembly works by setting up committees exclusively charged with examining specific matters. These committees are divided into standing and special committees. There are nine standing committees that correspond to the organization of the executive organs. Special committees can be established by a vote of the assembly.

The Tokyo Metropolitan Assembly, then, is the fundamental decision-making body. It enacts, amends, or revokes ordinances; it decides the budget. It even has the right to consent to the appointment of a vice governor.

The governor, himself elected by direct popular vote, is responsible for the supervision and the execution of administrative affairs, and can direct and supervise public organizations and meetings of the municipalities.

On paper the Tokyo Metropolitan Assembly is legislative, and the governor and those bodies beneath him are executive. In practice, however, there is considerable interaction on all levels, making for a relatively smooth-working bureaucracy.

This is most necessary. The difficulties of administrating a city as enormous as Tokyo are very great. This is seen even, or especially, in such homely details as garbage disposal. Tokyo produces 20,000 tons a day. This is burned or dumped—but now the waste places are largely filled. And since between 1965 and 1973 the amount of garbage doubled, and by now has undoubtedly

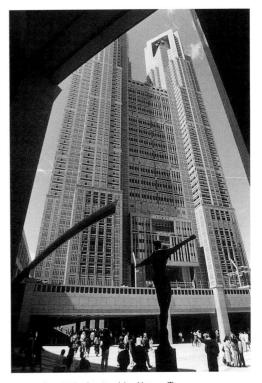

Tokyo City Hall, designed by Kenzo Tange.

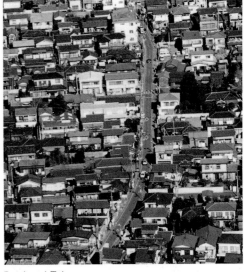

Residential Tokyo.

doubled again, the future is bleak. The present 10,000 garbage workers will shortly be insufficient.

Bureaucracies, too, tend to swell as their work increases. This is certainly true in Tokyo. The Tokyo government is busy designing new cities ("bed towns," the commuting residents call them) some distance from the capital, after having just built new quarters for itself.

Removed from its old offices in the Marunouchi section of downtown Tokyo, the metropolitan government is today housed in a new towering city hall amid the other highrises in Shinjuku. Here, from this new eminence, it leads the way for the future Tokyo.

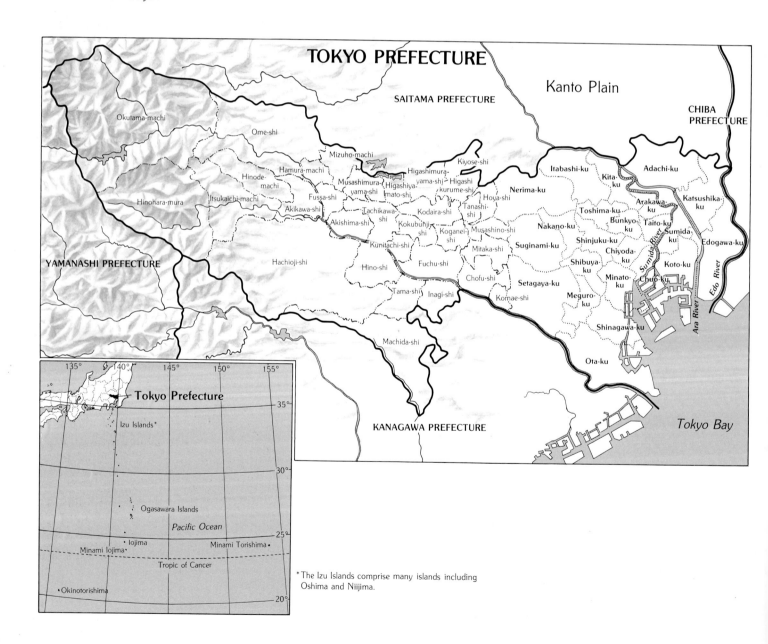

*The Izu Islands comprise many islands including Oshima and Niijima.

Transportation

Though one of the largest cities in the world, Tokyo has one of the finest public transportation systems. Its subways rival those of London and Paris for efficiency and number of people served, and it has a larger choice of alternative modes of transportation.

There are ten subway lines in Tokyo, covering a distance of some 120 miles (193 kilometers). These crisscross the city so that most locations are within walking distance of at least one station.

The system is laid out in such a way that finding one's way around is easy. Like the London underground, the lines of the Tokyo subway system are color-coded (the Marunouchi Line is red, for example: red coaches, red symbols on wall maps, red arrows on signs, and so on). In addition, each train is designated by its terminal—like the Paris system. This is matched by large station maps that indicate this terminal, all the stations in between, and the one where you are. It is easy to go where you want and impossible to get lost—in which way the Tokyo subway system is quite different from that of, say, New York. In addition, plaques in each station indicate the station you came from and the one you are going to, allowing you to double-check your direction and alerting you of your stop one station before you arrive.

The system is foolproof. And in addition, all signs are in Chinese-style characters, the phonetic *kana* alphabet (for children), and in the roman alphabet as well. And, depending upon line and time, trains arrive more frequently (and more promptly) than in any other of the world's various subway systems.

There is also an elaborate bus system, which, though convenient, can be difficult for the non-native rider to use. Romanized place names for the final destinations are often displayed (on the vehicles themselves if not at the stops), but in order to find out the stops in between, the driver must be consulted.

Though there was once an almost equally elaborate system of streetcar lines, this has mostly been discontinued, except for one small branch which runs between Waseda and Minowabashi. The curious may board it at Otsuka Station on the Yamanote Line and ride it on its rambles east.

The surface train system is much more extensive and much easier for the visitor to use. Three principal lines run through the center of Tokyo, and some twenty private railway lines extend into the suburbs.

Foremost among the principal lines is the Yamanote, a twenty-nine-station ring whose 21.5-mile (34.5-kilometer) loop circumscribes the center of the city. Though the loop has no terminal, many of its stops connect with subway lines crossing Tokyo and/or private suburban lines that take the commuter from central Tokyo out into the surrounding suburbs. The two other main lines crossing central Tokyo are the Keihin Tohoku Line, which runs from Saitama in the north to Yokohama in the southwest and beyond, following the Yamanote loop along its eastern and southern perimeters; and the Sobu/Chuo lines, which run east and west, slicing through the Yamanote loop and connecting the eastern prefecture of Chiba with the western outskirts of Tokyo.

Private lines radiate from many of the stations of the Yamanote and other lines. These range in length from the very long Odakyu Line and the Seibu Ikebukuro Line, with dozens of stops each, to the Tokyo Monorail, which connects central Tokyo with Haneda Airport in just a few.

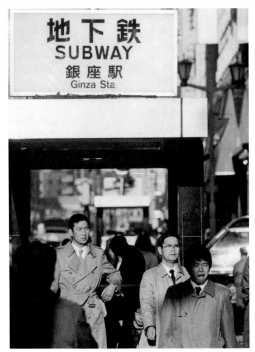

Typical subway entrance.

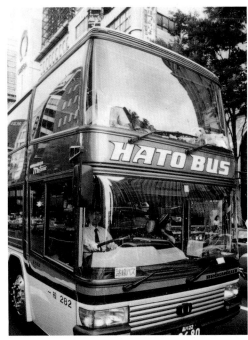

A double-decked sightseeing bus.

Recently many of the private railway lines have been connected directly with Tokyo's extensive subway system so that it is possible to travel directly from the city far out into the suburbs. For example, the Keio Line, coming in from the west, connects with the Shinjuku Subway Line, which cuts across the center of the city west to east before reaching Bakurocho Station, where the commuter may continue east into Chiba Prefecture by transferring to the Sobu Line.

There is, in addition, an elaborate system of elevated highways. There are some 84 miles (136 kilometers) of these crisscrossing Tokyo and accounting for many of the more futuristic aspects of Japan's capital.

These elevated expressways put an end, for a time, to Tokyo's celebrated traffic jams of twenty years ago. Now the volume of traffic is catching up to the capabilities of the two-decade-old expressway system.

Tokyo's overall transportation system has been criticized for its extreme sensitivity. It works well, daily moving by train, bus, and other means some twenty-two million of Tokyo's resident twenty-eight million, but it is fragile. There is no margin for error, so a small earthquake or tremor stops trains, a heavy rainfall slows motor traffic, and a light snowfall snarls everything. Still, given the enormous size of the city and its traveling masses, the system is rather marvelous.

Overall, however, Tokyo's public transportation system is a model of urban planning. Each year, officials from cities around the world visit Tokyo to study it. After all, where else is there a system that can boast trains that at peak time run as often as every two minutes, that rarely fall off schedule, and that efficiently serve eighteen million users daily?

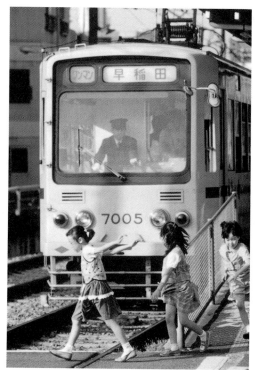

The last streetcar line.

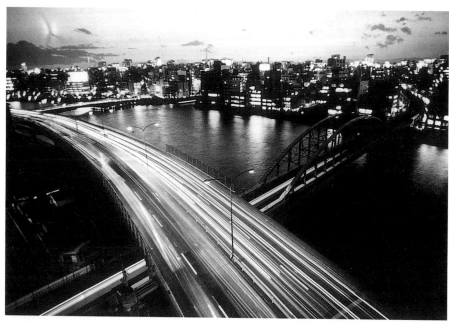

Elevated expressway along the Sumida River.

Accommodations

Tokyo is, among other things, a city of places to stay. There are nearly three thousand hotels in the city, ranging from the first-class and five-star to the "business" hotels and beneath. There are also many other lodging alternatives: the traditional inn (*ryokan*) and even the bed-and-breakfast (*minshuku*).

Ideally, in Japan one ought to stay at a *ryokan*, a Japanese inn. The best *ryokan* are not in the capital, however, and what few good ones there are usually require that the prospective guest be introduced. In any event, all cost as much or more than any of the first-class hotels. There are, however, a few *ryokan*-style places around the city which accept unintroduced transients and are not too expensive—considering that dinner and breakfast are included. One can find out where they are and how much they cost by referring to any of the local tourist-oriented foreign-language magazines or by going to the Tourist Information Center (TIC) in Yurakucho.

Among the more inexpensive places to stay in Tokyo are the many "business" hotels. Originally designed for businessmen staying in town overnight, these are utilitarian, even spartan. The rooms are small, the bathrooms, tiny. They are places to sleep in, nothing more.

For the even more budget-minded there are less expensive alternatives. There are the YMCA/YWCA lodgings and other youth hostels; there are "peoples' lodges" (the *kokumin shukusha*) and there are family-run lodges and *minshuku*; and some Buddhist temples take guests. Finding out where these are and if they have a room means going to the Tourist Information Center or the Japan Minshuku Center, also in Yurakucho.

At the bottom of any list of lodgings are the "capsule" hotels. These comprise dozens of "sleeping capsules," alongside of and on top of one another. Each is about a yard wide and two yards long. There is color TV, an alarm clock, an air-conditioner, a sprinkler system, and, of course, an emergency button.

Apartment-hunting in big, crowded Tokyo demands a degree of patience and cultural accommodation. Rooms which the Westerner finds confining seem vast to most urban Japanese. And Japanese spaces which are quite adequate for both the Japanese and the acclimated foreigner seem mere closets to the tourist—confining, even claustrophobic.

Space is at a premium. Tokyo proper holds 12 million people in a mere 830 square miles (2,150 square kilometers), and the most crowded of the wards, Toshima, has 57,000 people per square mile (22,000 per square kilometer). A square meter in Ginza costs about $25,000. The average Tokyo family of four occupies a mere 700 square feet (65 square meters) of space, about the same as an American one-bedroom apartment. No surprise, then, that a two-bedroom condominium in a good location can cost $400,000.

Perhaps, more than space, the residents should think in terms of time, and choose accordingly. In a city as large as Tokyo, *where* you live is as important as how big it is. If you choose to live outside the city, where more space is available for less money, you then must face the lengthy commute. The traveler should stay in the section of the city which he or she finds of most interest. If it is old Tokyo, then stay someplace near Ueno or Asakusa; if it is the new, then stay where you can see the towers of Shinjuku from your window.

A *ryokan*'s stone pathway—stepping into quietude and the old way.

Ryokan-style room, with coin television in the alcove.

Dining

"Tokyo is a giant spoon," the popular poet Shuntaro Tanikawa has written. "It's an indescribable mixture of foods—delicious, evil-tasting, sweet, spicy, fragrant, or reeking....You could dip in and ladle out forever...and never reach the bottom."

He was speaking figuratively, but the culinary metaphor is well chosen. Eating well in Tokyo is not a problem. The problem is choice—what and where to eat. There are nearly seventy thousand restaurants in the city and almost everything is available. Just name the cuisine—there are hundreds of places to eat foreign food in Tokyo.

But if one wanted that, why come to Tokyo? Here in the capital one might more fittingly sample the local cuisine and the regional specialties. And here, too, the choice is enormous, since three-quarters of those seventy thousand eating places are devoted to Japanese cuisine.

And most of them are good, for a bad Japanese meal is rare in Japan. Also, the majority of these restaurants are middle-priced establishments. There are, to be sure, very elegant *ryotei* where a meal costs as much as at the local Maxim's, and there are also a few greasy-spoon joints. On the whole, however, good food at average prices is the rule and a bad meal is a rarity.

If you go to the proper places, that is. The only rule is to stay away from restaurants that serve a variety of foods, in particular station buffets. Most restaurants in Japan specialize. This is why a bad meal is rare. So for sushi go to a *sushi-ya*, for eel to an *unagi-ya*, for pork to a *tonkatsu-ya*, and so on. Identification is no problem. Most restaurants have windows in which are displayed plastic models of the food served. Beware of restaurants, bars, and other *boîtes de nuit* that do not somewhere (window, wall, menu) exhibit a list of prices.

Though Tokyo itself does not make overmuch of its own cuisine, it has one. This nonchalance is in striking contrast to the attitude in Kyoto, where they place an almost French mystique on culinary excellence. Tokyo tempura, says the Kyoto connoisseur, is inedible compared to that of the old capital. This is simply not true. Tokyo tempura is perfectly good if you happen to like tempura. But it is not a Tokyo specialty.

Sukiyaki Tokyo-fashion is. It is made in a different way from Osaka–Kyoto sukiyaki. And traditional Osaka sushi is different from hand-shaped Tokyo sushi; and its miso (that bean paste which has its function in so many Japanese dishes) is different from Osaka miso. Also, Tokyo makes much of its seaweed and its long tradition of *senbei*, or rice crackers. In Ueno and Asakusa and other sections of downtown Tokyo, many stores specialize in them.

For those who are not particular in their eating habits, Tokyo has fitting facilities—there is a vast array of junk-food establishments. Not only are there the various finger-licking-good imports from America and Europe, with menus intact, there are also the Japanese imitations. And there is Japanese fast food: seaweed-wrapped rice balls with pickled plums in the middle, grilled squid on a stick, corn on the cob (for some reason a fast food favorite), sweet syrup over shaved ice, and so on. There is even a fast-food sushi: a conveyer belt carries sushi in from the kitchen. Certainly, this is not a connoisseur's delight, but for the curious it is an inexpensive entertainment.

On the whole, however, almost everything else is recommendable, and that is something one can say of the food of few other major cities.

Glamorizing the American fast food.

Lanterned *yakitori-ya*, a "*ya*," or shop, specializing in evening drinks and food for the everyman.

Dining Japanese: morsels in petit vessels.

Shopping

A hundred years ago early travelers to Tokyo were already talking about what to buy—in 1886 Henry Adams wrote home about all the shopping he was doing. And visitors today still exclaim about shopping opportunities in the capital—particularly now that consumption has become a major mode of Japanese life. There is so much of everything, and everything is for sale.

One of the complaints of the early traveler is still heard, however. The finest examples of traditional Japanese work, of what we would now call museum quality, have always been hard to find. "Porcelain worth buying is rare . . . kakemonos [hanging scrolls] are not to be got"—so wrote Henry Adams. If this was true a century ago, how much more so now. Extraordinary pieces are either in the museum or on their way there (or to private collections), with museum prices attached.

On the other hand, Japanese crafts have maintained their high level. Good traditional-type ceramics, excellent folkcraft products—all are available. Many prefectures have stores in Tokyo that have a selection of local products, often at low prices. Also, many department stores have a large selection of traditional handicrafts, of souvenir and higher quality.

Even more conspicuous are the products of contemporary Japan—in particular electronic ones. There are countless outlets throughout the city, but the main area is the well-known section of Akihabara.

The shopper is also confronted with 192 department stores and some 240,000 shops that sell everything from the latest in Tokyo fashions to plastic food samples. These items are, overwhelmingly, made in Japan, but there are also imported goods (at inflated prices) from around the world.

Tokyo is a true mart. Just as the Japanese have in large part become a nation of merchants, so their capital has become the world's largest market. There is almost nothing Tokyo does not sell.

The Ginza—"Japan's Fifth Avenue"—is itself something of a monument to conspicuous consumption. Here, as on the Rue St-Honoré, quality outlets line both sides of the street. Here, too, a like emphasis on probity and high culture. In Japan it is the merchant who is the vendor of culture. The department stores hold major art exhibitions: Cézanne at Isetan, van Gogh at Seibu. Everything is, in Tokyo, wedded to consumerism.

For those who want less probity and more style, there are the smart boutiques of Harajuku, Aoyama, and Omotesando. Here the customer is young—the kind of person for whom the enormous Japanese clothing industry was created. The turnover is so brisk that hot items sell out as soon as they hit the stores. Fashions change with a bewildering rapidity. Each season has its "must" outfit for the susceptible young.

In fact the only complaint one hears about shopping in Tokyo is that the products are so consumer-geared that nothing stays in stock for long. If you are looking for last season's windbreaker or school notebook, bathing suit or word processor, you are not apt to find it. They have either been sold out or withdrawn and something newer is in their place.

Thus, the exhilarating kaleidoscope of Japanese consumerism makes for some of the most exciting shopping anywhere in the world and—given the styles, the variations, the sheer choice—the most bewildering.

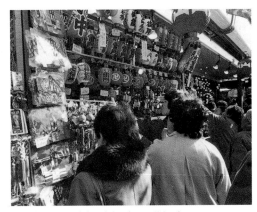

Temple memorabilia along the mall leading to the Asakusa Kannon Temple.

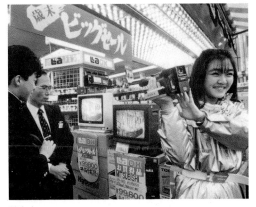

Akihabara.

Omotesando boutiques.

Entertainment

After a few days in Tokyo one begins to wonder if any more sheerly entertaining city exists. There is so much to do every day, and the opportunities seem to double after dark. Tokyo is frenetic, feckless, wide open, and in love with novelty—a perfect recipe for wall-to-wall entertainment. The choice is enormous and the scope is vast.

Of course, it all depends on what you want. For many just going into a Japanese department store is adventure enough for one day. From the food-packed sub-basements, up through the fashions and brand names and toys and robots, on through to the museum, the theater, the restaurant floor, and up to the roof, where the fish and plants are kept, the Tokyo department store is a world in itself and one that begs to be explored.

Then there are the museums—dozens of them. Ueno Park alone houses the enormous National Museum complex (which includes the National Museum of Art, the Archaeological Museum, and the Museum of Asian Art), the Museum of Western Art, the Tokyo Metropolitan Museum, the Museum of Science and Technology, and several smaller ones. And sprinkled throughout the city are many more: some specialize in woodblock prints or folkcrafts or a single artist; others offer great national or private collections.

In addition there are those devoted to Tokyo itself: the enormous Edo-Tokyo Museum on the Sumida River at Ryogoku Station; the Fukagawa Edo Historical Museum, a splendid reconstruction on the far side of the river; and the small but history-filled Shitamachi Museum by Shinobazu Pond in Ueno.

There is theater: the renowned Kabuki, daily showings at two theaters, the Kabuki-za and the National Theater; the Noh, usually showing with the Kyogen, at six Tokyo theaters on, usually, Sundays and Thursdays; and the Bunraku puppet theater comes up from Osaka for its seasons. There is the melodramatic nineteenth-century Shinpa, and also the Shingeki, or "new theater," which consists of foreign and Japanese plays in the Western style, playing in hundreds of smaller theaters throughout the city. There is the Takarazuka all-girl "opera," which comes up to Tokyo monthly, and the local productions of the London and Broadway musical hits. There is also the "underground," or "off-Ginza," movement of modern playwrights, there are cabaret-style performances, and there is Butoh and other advanced forms of dance-dramaturgy—all of these daily except, usually, Sunday.

And there is music and dance. There are six major symphony orchestras in Tokyo, three major opera companies, and many local ballet troupes. In addition, foreign opera and ballet companies are continually coming to Tokyo. Many foreign musicians make Tokyo a perennial stop, so there are usually famous instrumentalists, singers, and groups to hear. Too, Japan itself has many musicians, all of whom give yearly or seasonal recitals.

All of this, of course, most large cities have. It is just that Tokyo has so much more and so much more variety. And Tokyo also has the most of something that other large cities either have lost or never had—a really lively, truly frenetic nightlife.

Including places to drink. One of the country's earliest travelers (circa 1565), in Richard Hakluyt's account, said of the Japanese that "they feede moderately but they drink largely"; and one of the later, Truman Capote, called Japan "a barfly's Valhalla."

Theater entrance: everybody's a star.

Gallery exhibition.

Theater of all kinds, including Broadway imports.

Shinjuku nightlife.

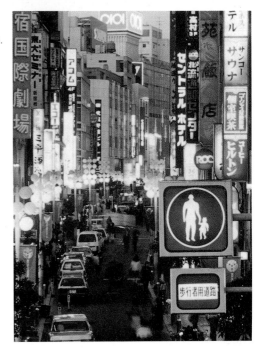

There are over forty-three thousand bars and nightclubs in Tokyo. They are of all types, from the elegant watering holes of Ginza and the glittering supper clubs of Akasaka to the cozy cubbyholes of neon-drenched Shinjuku—the largest entertainment area in Tokyo, perhaps in all of Asia and the world.

Here in this blinding maze of streets, brimming with neon and people, are thousands of places, most of them friendly, all of them noisy: workmen's bars with saké and grilled squid; white-collar bars with whiskey highballs, beer, and sing-along machines; hostess bars for company executives, with expensive scotch, smoked salmon, and no price lists anyplace (these places the uninitiated should avoid).

For most visitors perhaps the best, certainly the cheapest, entertainment will consist in just wandering the streets of Tokyo at night, where the animated displays seem to blossom and the neon bursts like fireworks. Probably no more openly hedonistic city (except, perhaps, Babylon) has ever existed, and nocturnal entertainment is, among other things, just that.

Tokyo Walking

The only way to really see a city is by walking around in it. Rome, Paris, London, New York—these are cities to walk in. Los Angeles, however, is not, for it is a city of wheels. Tokyo, on the other hand, is for feet. Only after being so explored does the city's true character begin to emerge.

That Tokyo is a merchant town, for example, and that it is an Asian one becomes apparent only to the walker. Shops line the street, spilling out onto it. Racks of clothing and sides of beef alike are shoved onto sidewalks. The fish shop's salty-fresh offerings are right before your eyes. On the Tokyo street, the sense of uninhibited consumption itself is everywhere apparent.

Along the more sedate avenues, the Ginza, for example, the goods stay indoors, but the abundance continues. Signs and banners proclaim—*kanji* grab and neon points. Signs, signs everywhere, all of them shouting a semiotic babble directed at the walker, the person going past.

This is very Asian. We would recognize this if the units were mangoes. But calculators and microwave ovens, instant cameras and word processors? The content startles.

Tokyo differs from Los Angeles in many other ways as well. Except for a few districts, Tokyo is a warren of streets and alleys and lanes. Isabella Bird laconically noted that Tokyo in 1880 "as a city, lacks concentration." If she saw it now she would certainly remark that there are not enough proper streets, that the sidewalks are not wide enough for the crowds, and that London has twelve times more parkland.

Nevertheless, or consequently, this whole enormous city is as comfortable and snug as a bird's nest, the byways having grown as need and inclination directed. Opportunities to remake the city after each of its various disasters have all been firmly resisted and the result is a city for people, not cars.

Still, as elsewhere, the battle between feet and wheels exists. There were, after all, twenty-eight million registered vehicles on the road in 1985. Whole sections of old Tokyo have been razed to make way for a new expressway, and many an intersection has been spanned with bridgelike walkways that the pedestrian must navigate.

Whole neighborhoods of old, twisted Tokyo have also fallen to developers and rising land prices. What was once a cozy tangle of alleys, shops, and homes becomes a series of square edifices of small distinction. And so another bit of the old tangle is destroyed. Yet, Tokyo's need for the human scale persists. Often the vanished neighborhood is, more or less, incorporated into the basement or top floor of the new structure. Here, again, are the same little bars, the same little restaurants, the warren reconstructed.

Another reason for walking is to admire the architectural diversity of the city. It is the ultimate in unrestrained display. Since zoning laws are few and concerned citizens' groups fewer still, the Japanese street is (unlike the very private Japanese house) very public.

Take modern uptown Tokyo architecture. Its diversity is astonishing. A glass-and-concrete box stands next to a traditional tile-roofed restaurant, which abuts a hi-tech open-girder construction, which overshadows a fake French farmhouse. The architectural oddity is often there to attract attention, and Tokyo buildings, indeed, have much the same function as the signs and banners that decorate them.

Posters and billboards also vie for the walker's eye.

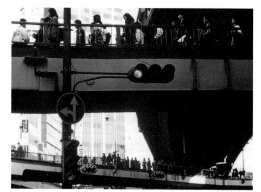

Pedestrian walkways over a major intersection and under an expressway.

One wonders, then, at Japan's reputation for conformity in this architectural mélange. One wonders also about Japan's noted sense of style. Rather, as in Henry James' London, "the city has no style, only innumerable attempts at style."

Here there is a resemblance to Los Angeles. As the art critic Hunter Drohojowska has said: "It is natural for anyone who likes Los Angeles to love Tokyo.... In both places, citizens value the interplay of surface and are unabashedly comfortable with artificiality [and] in both places, shopping has been elevated to an art form...."

Walking along Japanese streets exclaiming over the interplay of surfaces and the architecturally odd is one of the recreations of Tokyoites. The effect is that of a Disneyland gone awry, a feast of the world's architectural styles all in one place, the world made small, a playland for adults.

It can also have the effect of time-travel. Though very little is left of nineteenth-century Tokyo, there are still a number of pre–World War II buildings in downtown Tokyo, and these seem ancient indeed, particularly when found—as they often are—next door to the very latest in postmodern architectural display.

And there is—thanks to the back alleys and narrow passages, thanks to the architectural diversity—a sense of adventure and discovery still to be found in walking Tokyo. Washington, D.C., and Beijing are cities of vistas; you can take them in in a glance. Tokyo, like Rome, however, can be comprehended only by exploring its byways: it was originally for foot traffic, and today reveals its best side only to the walker.

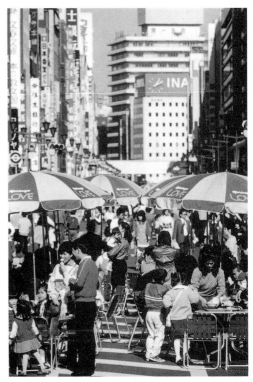

A Sunday on the Ginza.

Where, then, to walk? Well, that depends upon what kind of Tokyo you want. Modern, diversified Tokyo, the city of the twenty-first century, is found in Shinjuku (both above ground and in the vast underground malls), in Omotesando, and in the neon and turmoil that is Roppongi at night. Merchantile, prodigious Tokyo is found on the Ginza, in Akihabara, in the Ameya Yoko-cho market district of Ueno. "Old Tokyo" is found along the Sumida River around Asakusa, or in Yanaka, around the Nezu and Sendagi subway stops on the Chiyoda Line.

We "visitors" are used to large swaths of endeavor, and so we do not quite know what to think of the filigree of Tokyo. We know what to feel, however. Wandering the streets of Tokyo, we are aware of a sense of human proportion. To walk in Tokyo is to wear a coat that fits very well.

The proportions (except where Western-style Modern has taken over—West Shinjuku, for example) are all human. We raise our eyes to see structures of manageable proportions; we do not need to crane necks. And the streets are comfortably narrow, some being little more than paved pathways where walking two abreast is difficult. The scale is our own. Edward Seidensticker, a man who truly knows the city, has written that despite everything, Tokyo "has remained close to nature as has no other great city in the world."

That is to say, it has remained close to *human* nature. Its proportions, considerations, expectations, are all ours: as we approach the end of this century, as we stand peering into the next.

A Selected Bibliography

HISTORIES

Nishida, Kazuo. *Storied Cities of Japan.* Tokyo: Weatherhill, 1963.

Nouët, Noel. *The Shogun's City.* Folkestone, England: Paul Norbury, 1990.

Pérol, Jean. *Tokyo.* Seyssel: Champ Vallon, 1986.

Pezeu-Massabau, J. *L'Agglomération de Tokyo.* Paris: La Documentation Française, 1974.

Pons, Philippe. *D'Edo à Tokyo.* Paris: Gallimard, 1988.

Seidensticker, Edward. *Low City, High City: Tokyo from Edo to the Earthquake.* New York: Knopf, 1983.

————. *Tokyo Rising.* New York: Knopf, 1990.

Waley, Paul. *Tokyo Now & Then: An Explorer's Guide.* Tokyo: Weatherhill, 1984.

————. *Tokyo: City of Stories.* Tokyo: Weatherhill, 1991.

GUIDES

Baedeker's AA Tokyo. Norwich: Jarrold & Sons, 1983.

Bassin, Garry. *The Tokyo Transit Book.* Tokyo: Japan Times, 1983.

Camus, Anne. *Tokyo.* Tokyo: Editions Carletti, 1986.

Connor, Judith, and Yoshida Mayumi. *Tokyo City Guide.* Tokyo: Ryuko Tsushin, 1986.

Enbutsu, Sumiko. *Old Tokyo: Walks in the City of the Shogun.* Tokyo: Tuttle, 1993.

Flannigan, Thomas and Ellen. *Tokyo Museums.* Tokyo: Tuttle, 1993.

Japan Travel Bureau. *A Look into Tokyo.* Tokyo: JTB, 1984.

————. *Travel Guide: Tokyo.* Tokyo: JTB, 1985.

————. *Tokyo Shopping and Dining.* Tokyo: JTB, 1984.

Kami, Ryosuke. *Tokyo: Sights and Insights.* Tokyo: Tuttle, 1992.

Kennedy, Rick. *Good Tokyo Restaurants.* Tokyo: Kodansha International, 1992.

Kinoshita, June and Palevsky, Nicholas. *Gateway to Tokyo.* Tokyo: Kodansha International, 1993.

Miyao, Shigeo and Dunbar, Fred. *Tokyo.* Tokyo: Hoikusha Color Book, 1984.

Pearce, Jean. *Foot-loose in Tokyo.* Tokyo: Weatherhill, 1976.

————. *More Foot-loose in Tokyo.* Tokyo: Weatherhill, 1984.

Tokyo 1986. New York: Fodor's Guides, 1986.

Turrent, John. *Around Tokyo,* Vol. II. Tokyo: Japan Times, 1983.

————, and Lloyd-Owen, J. *Around Tokyo,* Vol. I. Tokyo: Japan Times, 1982.

Wurman, R. S. *Tokyo Access.* Los Angeles: Access Press, 1984.

GENERAL

Alcock, Rutherford. *The Capital of the Tycoon.* London: Longman, 1863. Reprinted, New York: Greenwood, 1969.

Atlas Tokyo: Edo/Tokyo Through Maps. Tokyo: Heibon-sha, 1986.

Bales, Mitzi. *Tokyo.* New York: Gallery Books, 1985.

Black, John R. *Young Japan: Yokohama and Yedo, 1858-79.* New York: Pratt, 1883. Reprinted, New York: Oxford University Press, 2 vols., 1968.

Caiger, G. *Tell Me About Tokyo.* Tokyo: Hokuseido, 1939.

Kirkup, James. *Tokyo.* London: Phoenix House, 1966.

Maraini, Fosco. *Tokyo.* Amsterdam: Time-Life Books, 1976.

Pérol, J. *Tokyo.* P.U.F., Collection: Une Ville un Écrivan. Paris, 1986.

Popham, Peter. *Tokyo: The City at the End of the World.* Tokyo: Kodansha International, 1985.

JANUARY

1-3 Though the first is the national holiday, the following two days are usually also taken off; most stores are closed.

2 The public is allowed inside the Imperial Palace compound to offer New Year's greetings to the imperial family, a ritual called *ippan sanga*.

6 Dezomeshiki. Tokyo firemen demonstrate traditional Edo-period acrobatic skills using bamboo ladders. At Harumi Pier (Hamamatsucho Station, Yamanote Line).

15 Coming-of-Age Day (Seijin no Hi), national holiday. Special shrine ceremonies for young adults celebrating their twentieth year.

Mid-month Hatsubasho. The first *sumo* tournament of the New Year is held at Kokugikan Sumo Stadium (Ryogoku Station, Sobu Line).

15-16 Boro Ichi. Popular crafts fair, held on Daikan Yashiki-mae thoroughfare (take bus from west side of Shibuya Station, alighting at the Kamimachi bus stop). *See also* December.

24 Jizo Festival. At Koganji Temple in Sugamo (Sugamo Station, Yamanote Line).

24-25 Usokae. Traditional festival at Kameido Tenjin Shrine (Kameido Station, Sobu Line).

28 Daruma Doll Fair. At the Takahata Fudo Temple in Hino (Takahata Fudo Station, Keio Line).

Late month The Camellia Festival on Oshima Island. Through mid-March.

FEBRUARY

3 or 4 Setsubun. The bean-throwing ritual to drive out evil and welcome spring. At various temples in Tokyo, the more popular being Asakusa Kannon Temple*, Zojoji Temple in Shiba Park (beside the Tokyo Prince Hotel), and Hie Shrine*.

11 National Foundation Day (Kenkoku Kinenbi), national holiday.

Mid-month Plum-Blossom Festival. At the Yushima Tenjin Shrine (Yushima Station, Chiyoda Line). Through mid-March.

MARCH

3-4 Daruma Doll Fair. At Jindaiji Temple in Chofu (take bus from Chofu or Tsutsujigaoka on the Keio Line or Mitaka Station on the Chuo Line).

Second Sunday Fire-Walking Ceremony (Hiwatari). At Takao, a short walk from the station (Takaosanguchi Station, Keio Line; take a bus from Takao Station, Chuo Line).

18 The Golden Dragon Dance (Kinryu no Mai). At Asakusa Kannon Temple*.

All month Plum-Blossom Viewing. Some of the nicer locations include Kameido Tenjin (Kameido Station, Sobu Line), Higashi Gyoen (Otemachi Station, numerous lines), and Hama Rikyu (Hamamatsucho Station, Yamanote Line). Among the sites in the outlying areas are Yoshino Baigo (Hinatawada Station, Ome Line), Itsukaichi Baigo (Itsukaichi Station, Itsukaichi Line), and Mogusa-en (Mogusa Station, Keio Line).

APRIL

Early April Cherry-Blossom Viewing. Prime locations include Ueno Park*, Aoyama Cemetery (Nogizaka Station, Chiyoda Line), Shinjuku Gyoen (Shinjuku Gyoen-mae Station, Marunouchi Line), Yanaka Cemetery (Nippori Station, Yamanote Line), and Chidorigafuchi (Kudanshita Station, Tozai or Shinjuku lines). Through mid-April.

8 Birth of Buddha. Large-scale activities held at the Asakusa Kannon Temple* and the Ikegami Honmonji Temple (Ikegami Station, Ikegami Line).

29 Greenery Day, national holiday.

End of the month Wisteria Festival (Fuji Matsuri). At Kameido Tenjin Shrine (Kameido Station, Sobu Line). Through early May.

End of the month Azalea Festival (Tsutsuji Matsuri). At Nezu Shrine (Nezu Station, Chiyoda Line). Through early May.

MAY

3 Constitution Day (Kenpo Kinenbi), national holiday.

5 Festival of Darkness (Kurayami Matsuri). All-night festival at Okunitama Shrine (Fuchu Station, Keio Line).

Second weekend Kanda Festival. A large spring festival with portable shrines, et cetera, at Kanda Myojin Shrine (from Ochanomizu Station, Chuo Line).

Third weekend Sanja Matsuri. Tokyo's largest and liveliest festival. The portable shrine processions start Sunday morning from the Asakusa Kannon Temple*.

31 Potted Plant Market. At Sengen Shrine, next to Asakusa Kannon Temple*. Through June 1. Also, June 30 to July 1.

JUNE

10-16 Sanno Matsuri. One of the large Tokyo festivals. At Hie Shrine*.

Mid-month Iris Viewing. Meiji Shrine*, Mizumoto Park (bus from Kanamachi Station, Chiyoda Line), and Horikiri Shobuen Iris Garden (Horikiri Shobuen Station, Keisei Line).

End of the month Fuji Matsuri. Tokyo festival to open climbing season at Mount Fuji. At Asakusa Sengen Shrine (Asakusa Station,

Asakusa or Ginza lines) and Fuji Shrine (Komagome Station, Yamanote Line).

JULY

6–8 Morning-Glory Fair (Asagao-ichi). At Kishibojin Temple (Iriya Station, Hibiya Line).

9–10 Ground-Cherry Fair (Hozuki-ichi). At Asakusa Kannon Temple*.

Mid-month Summer Evening Festival. At Ueno Park*, environs of Shinobazu Pond, until mid-August.

Last Saturday Fireworks. Locations include the Sumida River (Asakusa Station, Ginza or Asakusa lines), the Edo River (Kanamachi Station, Keisei Line), the Ara River (Takashimadaira Station, Mita Line), and the Tama River (Tamagawa Station, Keio Line).

AUGUST

4–6 Pottery Fair (Setomono-ichi). At Ningyocho (Ningyocho Station, Hibiya Line).

15 Fukagawa Festival. Portable shrine parade at Tomioka Hachimangu Shrine (Monzen-nakamachi Station, Tozai Line). Every 3 years.

27–28 Awa Festival. A large dance festival held in Koenji (Koenji Station, Chuo Line).

SEPTEMBER

15 Respect-for-the-Aged Day (Keiro no Hi), national holiday.

23 Autumnal Equinox Day (Shubun no Hi), national holiday.

End of the month Grand Tokyo Festival. A new city-wide festivity featuring, among other things, parades on the Ginza. Through early October.

OCTOBER

1 Tokyo Citizen's Day (Tomin no Hi), school holiday.

First Saturday Kakunori. Log-rolling acrobatics, near the bridge Kurofunebashi in Monzennakacho, the timber wholesale district (Monzennakacho Station, Tozai Line).

11–12 Oeshiki Festival. Ikegami Honmonji Temple (Ikegami Station, Ikegami Line).

18 The Golden Dragon Dance (Kinryu no Mai), Asakusa Kannon Temple*.

Mid-October Chrysanthemum exhibitions at Asakusa Kannon Temple* and Meiji Shrine*.

31 Autumn Festival. At Meiji Shrine*. Includes archery demonstration. Through November 3.

NOVEMBER

15 Shichi-go-san ("Seven-Five-Three"). A yearly ceremony for boys aged five and girls aged three and seven. Held in various shrines, among the most popular being Meiji Shrine*, Kanda Myojin Shrine (Ochanomizu Station, Chuo or Chiyoda lines), and Hie Shrine*.

During the month Tori no Ichi, or "bird fairs." Lucky bamboo rakes are sold. Held on the days of the cock according to the old lunar calendar. At Otori Shrine in Asakusa (between Minowa and Iriya stations on the Hibiya Line), Otori Shrine (Meguro Station, Yamanote Line), Hanazono Shrine (Shinjuku Station, various lines), and other locations.

DECEMBER

14 Gishi-sai. Festival commemorating the famous vendetta of the forty-seven *ronin*. At Sengakuji Temple (Sengakuji Station, Asakusa Line).

15–16 Boro-ichi. Crafts fair, held twice a year on the Daikan Yashiki-mae thoroughfare (take bus from Shibuya Station, alighting at the Kamimachi bus stop). *See also* January.

17–19 Battledore Fair (Hagoita-ichi). At Asakusa Kannon Temple*.

23 Emperor's Birthday, national holiday.

28 Year-end fairs at Fukagawa Fudo-son Temple in Monzen-nakacho (Monzen-nakacho Station, Tozai Line), Meguro Fudo-son Temple in Meguro, et cetera.

31 Around midnight millions congregate to see the New Year in, the most popular places being Meiji Shrine* and Asakusa Kannon Temple*. Trains and subways run all night.

*Locations of some of Tokyo's most popular attractions:

Asakusa Kannon Temple: Asakusa Station, Ginza or Asakusa lines.
Hie Shrine: Near the Capitol Tokyu Hotel, Akasaka or Akasaka-mitsuke stations, various lines.
Meiji Shrine: Harajuku Station, Yamanote Line; Meiji Jingu-mae Station, Chiyoda Line.
Ueno Park: Across from Ueno Station, various lines.

NOTE: The dates of festivals and events may vary from year to year. Check the events columns in the local English-language publications or with the Tourist Information Center (TIC) in Yurakucho (Tel. 3502-1461/2).